THE BUSCH-REISINGER MUSEUM

HARVARD UNIVERSITY

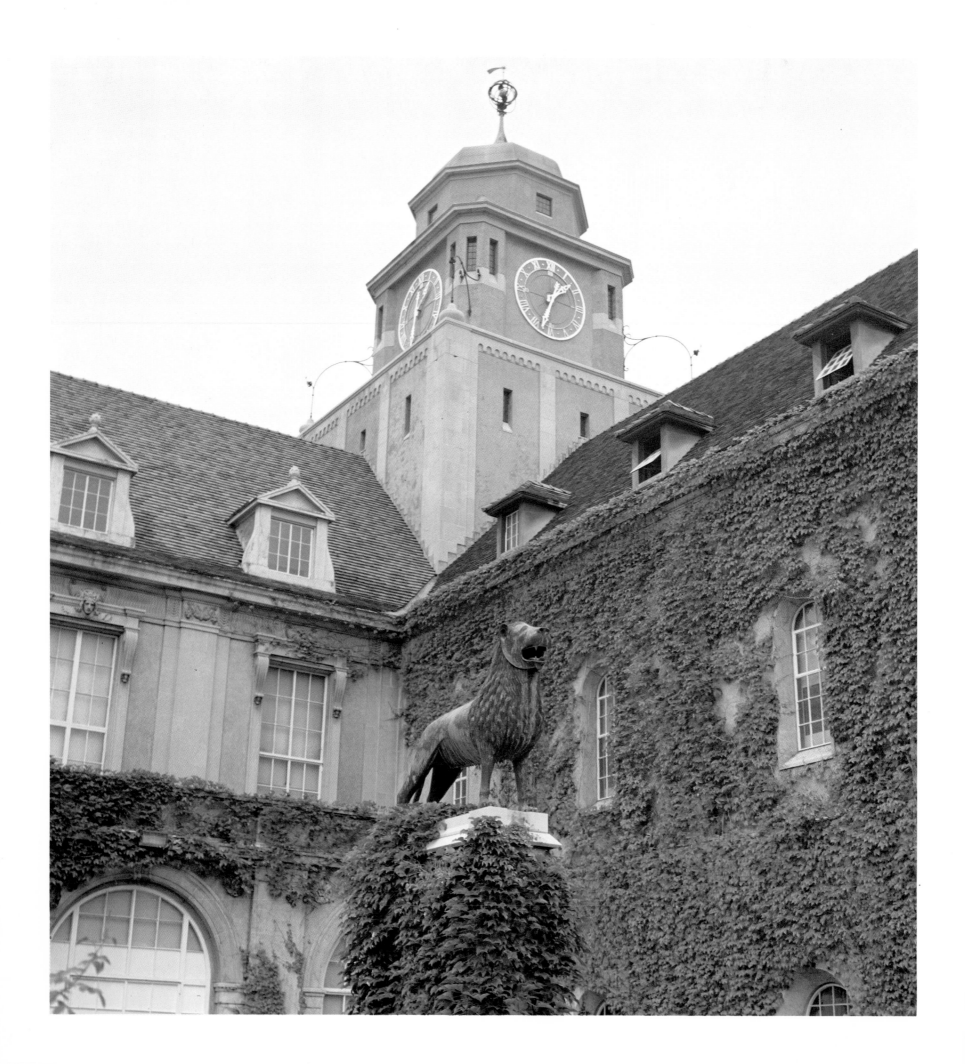

THE BUSCH-REISINGER MUSEUM

HARVARD UNIVERSITY

PREFACE BY SEYMOUR SLIVE

INTRODUCTION BY
CHARLES HAXTHAUSEN

WITH PHOTOGRAPHS BY
DAVID FINN AND AMY BINDER

ABBEVILLE PRESS, INC.

On the front cover:
Self-Portrait in Tuxedo by Max Beckmann
Commentary on page 19.

Facing the title page:
Bronze cast of the *Brunswick Lion* (1166) in the Museum courtyard

On the back cover:
Madonna and Child, a sculpture by an anonymous Tyrolean artist
Commentary on page 104.

Unless otherwise noted, oil paintings are on canvas, and graphic arts are on white paper; and accession numbers refer to the Busch-Reisinger Museum.

The publisher wishes to thank *Apollo* magazine for permission to reproduce parts of the Introduction, which were published in the May 1978 issue.

DESIGNER: ULRICH RUCHTI

ISBN: 0–89659–138–7
Library of Congress Catalog Card Number: 80–65261

Printed and bound in Japan.

CONTENTS

PREFACE

Fifty years ago the Busch-Reisinger Museum had but two original works of art, a lackluster portrait of Kaiser Wilhelm II and a rather tattered Renaissance tapestry. Today, the Museum owns over twelve thousand objects ranging from late medieval, Renaissance, and baroque sculpture, sixteenth-century painting, and eighteenth-century porcelain to a large and distinguished collection of twentieth-century German works. The Museum houses major master works of expressionism and the largest collection of Bauhaus materials outside of Germany, as well as the archives of Lyonel Feininger and Walter Gropius.

The remarkable growth of the Busch-Reisinger is due to the vision of one man, Charles L. Kuhn, who became curator of the Museum in 1930. Recognizing the importance of learning from original works of art, Kuhn embarked on a policy of acquiring originals to supplement the plaster casts already in the collection. His policy was soon endorsed by a group of friends of the Museum. Their generous help and his knowledge, discrimination, and judicious use of the Museum's limited financial resources enabled Kuhn to amass a strong collection of Central and Northern European art.

The Busch-Reisinger Museum and the Fogg Art Museum—Harvard University's two art museums—are central to the teaching of art history at Harvard. Their rich holdings constitute a unique resource enabling students to gain firsthand familiarity with important aspects of their visual heritage. This book presents highlights of both collections.

The present volume is the result of the combined efforts and support of a number of people. We are especially indebted to Charles W. Haxthausen for his Introduction. We thank Gabriella Jeppson, Prof. John Coolidge, Emilie Dana, Karen Davidson, Eleanor M. Hight, Marion True McCaughan, and Martha Wolf who assisted in research for the commentaries in the book. We are deeply beholden to David Finn and Amy Binder for the many beautiful photographs they made expressly for the volume. Finally, publication of the book owes much to the desire of Harry N. Abrams and Robert E. Abrams to make the collections housed in the Busch-Reisinger Museum known to a wider public. Our debt to both of them is enormous.

SEYMOUR SLIVE
DIRECTOR

INTRODUCTION

Harvard University has long been a center for the study of art history and the training of museum professionals. Crucial components of this tradition are the University's art museums, the Fogg and Busch-Reisinger, and the Arthur A. Houghton Library, with its outstanding holdings of archival material and rare illustrated books relating to the history of art. Together, these resources constitute one of the major art collections in the world.

The Busch-Reisinger Museum is a unique part of this complex: it is the only institution in the Americas which is exclusively devoted to the arts of Central and Northern Europe. Although the Museum's collections have always encompassed the culture of a broad geographical area, from the beginning their greatest strength has been the art of German-speaking Europe, and today the Museum is one of the major repositories of expressionist and Bauhaus art. These holdings are supplemented by a smaller but distinguished collection of Central and Northern European art from other countries and periods.

Although the Busch-Reisinger Museum today houses over twelve thousand art objects, its original name and purpose were different. It was founded at the turn of the century as the Germanic Museum, and its mission at that time was the acquisition and exhibition of *reproductions*—not originals—of major works of Central and North-

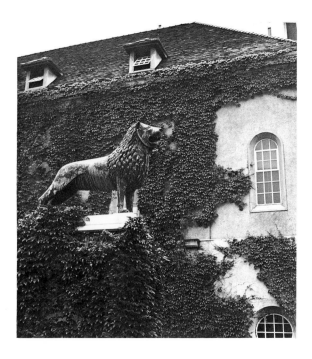

Bronze cast of the *Brunswick Lion* (1166) in the Museum courtyard.

ern European art. The institution was conceived and created by Kuno Francke, a literary historian, who held a chair as Professor of Germanic Civilization in Harvard's Department of Germanic Languages and Literatures. Francke, author of a history of German literature in its social context, held a Hegelian belief in the cultural unity of each epoch and a commitment to teaching German literature as an integral part of the broader *Kulturgeschichte* of a particular period. The mission of the Germanic Museum, according to Francke's foreword to the first edition of the Museum's guide (1906), was "to illustrate by reproductions of typical works of the fine arts and the crafts the development of Germanic culture from the first contact of Germanic tribes with the civilization of the Roman Empire to the present day." At a time when European travel was a rarity for the university student, Francke wanted to offer his pupils the opportunity of experiencing and studying, through the medium of full-scale facsimiles, important monuments of the visual arts of German-speaking Europe. But he also had a more ambitious goal: he hoped that the Germanic Museum would "form a bond of union between the various studies relating to different phases of national life." He lamented the growing specialization of modern scholarship and desired that the Museum would help to counteract this tendency "by becoming a meeting ground for the art student and the philologist, the student of political as well as literary history."

The Museum was officially opened to the public on Schiller's birthday in November 1903. In addresses made at the dedication ceremonies, both Francke and the president of Harvard, Charles

Left, *Kneeling Youth* (1923) by Georges Minne. Right, *Seated Youth* (c. 1930) by Hermann Blumenthal.

The Bremen Town Musicians
(1951) by Gerhard Marcks.

William Eliot, emphasized that the new institution was not to be a *German* Museum, but a *Germanic* one, an ethnological concept which for them embraced not only the Germans, Austrians, and Swiss, but the English, Dutch, and Scandinavians as well. In practice, however, the collections of the Museum did not reflect this diversity evenly. Though Francke's concept may have been ethnically broad, his own national origins and intellectual interests were German, and from the beginning the strength of the Museum, then as today, was its representations of the art of Germany. Indeed, it was major donations from the Emperor William II himself which formed the nucleus of the Museum's collections: excellent full-scale plaster casts of such monuments as the eleventh-century bronze doors from the Church of Saint Michael in Hildesheim, the thirteenth-century golden portal from the Church of Our Lady in Freiberg in Saxony, and the rood screen from the Cathedral of Naumburg—all of which can still be seen in the Museum today. These gifts encouraged others, from such donors as the King of Saxony, the Prince-Regent of Brunswick, and the Prince-Regent of Bavaria.

The Germanic Museum was first located in the basement of the Harvard College gymnasium, hardly an inspiring setting for such a collection. Within a year of its official opening the burgeoning collection of casts, reproductions, and books had outgrown its modest

temporary quarters, dramatizing the need for a proper museum facility suitable for the effective display of monumental sculpture.

Happily, Francke found in the United States a wealthy and munificent patron in the person of Adolphus Busch, a German-American brewer from St. Louis. In 1909 and 1910 Busch contributed over $250,000 towards the $300,000 building fund, enabling Francke to hire an architect to draw up plans for the new building. Busch wanted a leading German architect to design the Museum, and Francke hired German Bestelmeyer of Dresden, a very successful conservative architect, who had designed institutional edifices in a variety of historical and national styles. Among his works were the Central Hall of the University of Munich, a building in Italian Renaissance style which Francke praised as "an undoubted work of genius," and an extension to the Germanisches Nationalmuseum in Nuremberg, an institution which inspired the concept of Harvard's Germanic Museum. Bestelmeyer's historicism and stylistic flexibility made him an ideal choice, since Francke wanted a structure "which, instead of repeating the meaningless formulas of classicist imitation, should be an original artistic expression of what the museum stands for—the history of German culture." Bestelmeyer produced a building with three spacious halls—Romanesque, Gothic, and Renaissance, with their respective characteristic stylistic features—to accommodate the Museum's monumental sculpture. It is a massive but gracious building, with a distinctively German architectural charm that is as much an attraction to many visitors as the Museum's contents.

It is a sad irony that construction of the building at last began in July 1914, only weeks before the outbreak of a war that would drastically undermine the German-American cultural understanding that Francke had tirelessly striven to promote. When, in 1917, the United States declared war on Germany, the completion of the building had to be postponed, and it was not until 1921 that the new Germanic Museum was able to open its doors to the public.

Though Francke reached retirement age in 1922, he continued to direct the Museum as curator emeritus until his death in 1930. At that time there was an administrative reshuffling in which the Germanic Museum became affiliated with the Fogg Art Museum and the Department of Fine Arts, after three decades of association with the Department of Germanic Languages and Literatures. Professor Charles L. Kuhn, a young art historian, was named curator in 1930, a post he was to hold for thirty-eight years. Kuhn immediately instituted a far-reaching change of policy, initiating the acquisition of

original works of art to supplement the impressive collection of plaster casts. Already during the first year of his tenure he acquired an important monumental sculpture, *Crippled Beggar* (Page 70) by Ernst Barlach. It is one of two casts of the figure, which belonged to a projected series of sixteen figures entitled *The Community of Saints*, intended for niches in the facade of the Church of St. Catherine in Lübeck. This purchase and many of those of the next several years were made possible by donations from Edward M.M. Warburg, a recent graduate of Harvard College. During the early 1930s Kuhn's most important acquisitions were works of contemporary German art; he showed a judicious eye in his choice of watercolors, drawings, and graphic works by such artists as Klee, Feininger, Kandinsky, Grosz, Macke, and Nolde, and sculptures by Marcks, Kolbe, and Lehmbruck, in addition to further works by Barlach.

However, just as the Museum again seemed to be on the threshold of a flourishing era, political events in Germany undermined this promising development and destroyed any possibility of a meaningful and productive cultural exchange. Moreover, the very artists whom Kuhn was collecting so avidly were declared "degenerate" by the Nazis and their works were purged from German museums. Like other museums outside of Germany, the Busch-Reisinger gradually acquired a number of art works that had once been the proud possessions of German public collections. The first of these acquisitions, indeed the first major oil painting which Kuhn purchased, was Max Beckmann's magisterial *Self-Portrait in Tuxedo* (Page 19), painted in 1927 when the artist was at the height of his powers. The Berlin National Gallery had bought this picture in 1928 and it quickly became one of the most celebrated Beckmanns of its time—a status it once again enjoys in our own. In 1941 Kuhn bought it for $400.

After the United States entered the Second World War, there was little sympathy or even tolerance for the idea of a Germanic Museum, and in 1942 it was forced to close its doors for the second time in twenty-five years. Shortly after it reopened in 1948, it was renamed the Busch-Reisinger Museum in honor of the St. Louis family that had been its most generous supporter. The new era which began at this time proved to be the most dynamic in the Museum's history. At a time when there was little international interest in the art of German-speaking Europe, Kuhn began acquiring many of the paintings which are today widely regarded as masterpieces. For example, two important German expressionist works, which had formerly belonged to the Folkwang Museum in Essen, Ernst Ludwig Kirchner's *Self-Portrait with Cat* (Page 31) and

Erich Heckel's triptych *To the Convalescent Woman* (Page 37), were purchased by the Busch-Reisinger Museum in 1950. With the same judicious foresight Kuhn also began collecting art works, artifacts, and documents related to the Bauhaus, Germany's most influential contribution to modern art and design. In this effort he was aided and encouraged by Walter Gropius, founder and first director of the Bauhaus, who since 1937 had been a professor at the Harvard Graduate School of Design.

The Bauhaus collection grew rapidly, thanks to gifts from many donors, most of them former associates of the Bauhaus, such as Anni and Josef Albers, Herbert Bayer, Julia and Lyonel Feininger, Ludwig Mies van der Rohe, and Sibyl Moholy-Nagy. Sibyl Moholy-Nagy, for example, donated the *Light-Space Modulator* (Page 61) designed and built by her husband between 1922 and 1930. This epoch-making metal construction was one of the boldest and most imaginative creations stemming from the wedding of art with modern technology, and it became the archetype for the new medium of kinetic art.

Charles L. Kuhn Hall with casts of the Golden Portal from the Frauenkirche at Freiberg in Saxony (13th century) and the Bernward Column from Hildesheim (c. 1020). In the foreground are *Spring* and *Summer,* attributed to Johann Joachim Günther.

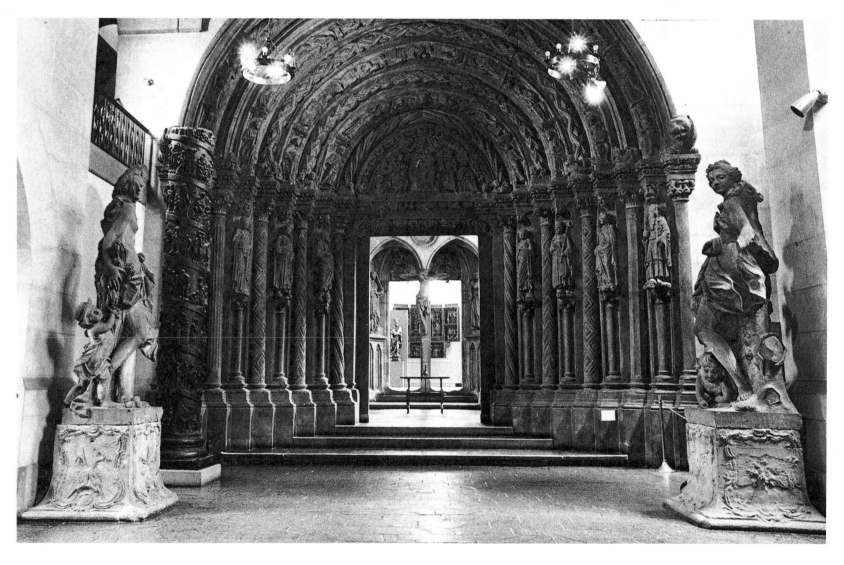

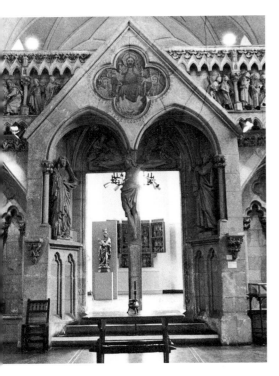

A cast of the rood screen from Naumburg Cathedral (13th century).

Quantitatively, however, the greatest gifts to the Museum's Bauhaus collection were those by the Feiningers and Gropius. The latter donated drawings, plans, blueprints, presentation boards, and photographs documenting his illustrious career from its very beginnings up to his practice in Cambridge. It is ironic that Bestelmeyer's museum, with its historicist evocations of Germany's architectural past, has become the repository for the archives of one of the most innovative and ingenious pioneers of twentieth-century architecture. Moreover, Gropius's first major building, the Fagus Shoe Factory—a revolutionary work of 1910–11, in which the walls were dissolved into a translucent skin of glass encasing a thin steel structure—was exactly contemporary with Bestelmeyer's massive design for the Germanic Museum.

In 1963 Julia Feininger made a major gift from her husband's estate, consisting of oil sketches, letters, diaries, ephemera, graphic works, a complete photo archive of the painted *oeuvre*, and, most important, about 5,000 drawings and sketches from Feininger's entire career. Feininger had been one of the first artists to be acquired by Kuhn, and even before the bequest, the Museum owned several important works, including *Bird Cloud* (Page 24) of 1926, one of the painter's best-known compositions.

While the greatest strength of the Busch-Reisinger Museum is incontestably its twentieth-century collection, it also has important holdings of late medieval, Renaissance, and baroque painting and sculpture. Charles Kuhn began to acquire earlier art in the 1930s, and in 1932 he obtained an early sixteenth-century Thuringian lindenwood triptych, which today graces the Museum's Gothic chapel. However, most of the acquisitions of earlier art were made in the 1950s and 1960s.

Altogether the Fogg and Busch-Reisinger museums own more than ninety pieces of Central European sculpture from the thirteenth until the end of the nineteenth centuries. Among this group is a *Saint Anthony Abbot* (Page 103) attributed to Tilman Riemenschneider, an exquisite steatite relief by Peter Flötner (Page 93), and four colossal rococo sandstone sculptures, representing the four seasons, which once adorned the gardens of the Palace of Bruchsal and have been attributed to Johann Joachim Günther, court sculptor to the Prince-Bishop of Speyer. One of the jewels of the Museum collection is the Tyrolean *Madonna and Child* (Page 105), a polychromed wood sculpture of about 1430, an excellent example of a devotional type known as the *schöne Madonna*, which was very popular in German-speaking Europe during the fifteenth century.

The Busch-Reisinger Museum's collection of older paintings is

strongest in the fifteenth and sixteenth centuries, with important works by the Dutch, Flemish, and German Schools. There are paintings of religious subjects by Lucas van Leyden, Gerard David, Adriaen Isenbrandt, and Dirck Bouts, and portraits by Joos van Cleve, Jan Gossaert, Barthel Bruyn, and from the workshop of Lucas Cranach the Elder. One of the finest paintings in the collection is a work of exceptional quality and considerable scholarly interest. It is one of the numerous Flemish variants of Dürer's *Saint Jerome in His Study*, now in Lisbon, which the artist painted in Antwerp in 1521 for a Portuguese patron. Dürer's composition was copied by Joos van Cleve (Page 47) and was repeated in the Netherlands innumerable times during the first half of the sixteenth century. The Busch *Saint Jerome* has been variously attributed to Joos and to Quentin Massys and their respective circles.

Although the Busch-Reisinger's collections are rich in distinguished works, it is the Museum's pedagogical mission which constitutes its uniqueness among the world's important collections of Central and Northern European art. From introductory courses to graduate seminars, students acquire a knowledge and understanding of the visual arts through a continuing encounter with original art of high quality. The educational tradition represented by the Fogg and Busch-Reisinger museums has produced not only distinguished scholars and curators, but many discriminating collectors and patrons as well. Although the holdings of the Busch-Reisinger have changed dramatically since it was founded by Kuno Francke, his statement of the Museum's educational purpose, which he delivered at the dedication ceremonies over seventy-five years ago, still holds today:

The most immediate and obvious as well as the most general service rendered to the student by such a museum is its appeal to the eye. Goethe somewhere says: 'What we have not seen with our own eyes is really no concern of ours.' Although not meant as such, this word of Goethe's is a severe and just indictment of much of what passes for critical scholarship. All too often critics forget that their first and fundamental task is to see a given object, be it a drama, a statue, or a social fact, to become familiar with its dimensions, its outline, its proportion; to take it in, so to speak, as a whole. . . . The primary office, then, of such a museum as this is to force the objects themselves upon the attention of the college student, to engender the habit in him of gazing and re-gazing, to adapt his sensuous perception to the objects of his study.

<div align="right">

CHARLES W. HAXTHAUSEN
CURATOR

</div>

PAINTINGS

Josef Albers

(1888–1976) *Homage to the Square: Against Deep Blue,* 1955, oil on composition board, 61 × 61 cm. Anonymous gift, 1963.28.

In 1933 Albers left Germany where he had been affiliated with the Bauhaus and came to the United States where he taught at Black Mountain College in North Carolina and then at Yale University. His series of paintings, *Homage to the Square,* begun in 1949, represents the synthesis and refinement of his previous work. As his lucid statements emphasize, Albers was interested in the relativity and interaction of color as well as effects of form, color, and space. All of the *Homage* series are meticulously conceived works. Albers devised four compositional arrangements for the series, one with four nested squares and three variants using only three squares. Each composition was precisely measured on unyielding composition board rather than on canvas and they were painted as evenly as possible. Each one succeeds in stripping color of its descriptive or associative elements, making it a medium in its own right and eloquently demonstrating that color can appear to change when it interacts with other colors and when light changes.

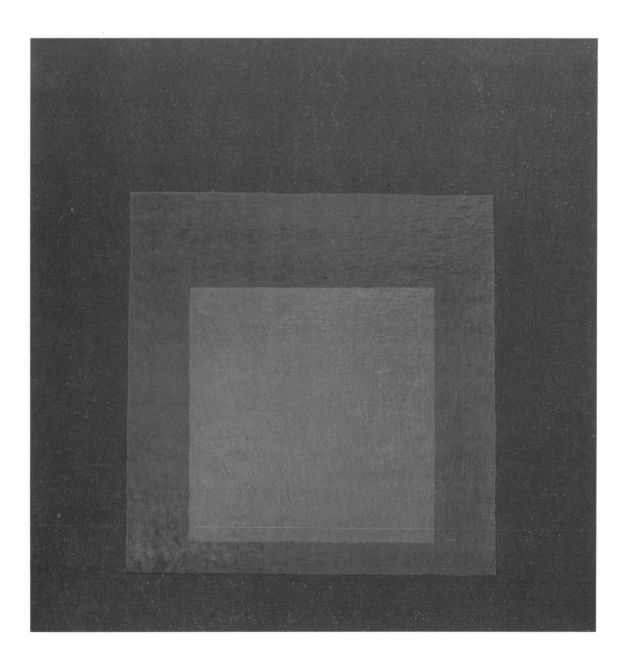

Josef Albers

(1888–1976) *Overlapping*, 1927, sandblasted
glass panel, 60.1 × 27.9 cm. Purchase, Kuno
Francke Memorial Fund and the Germanic
Museum Association Fund, 1949.261.

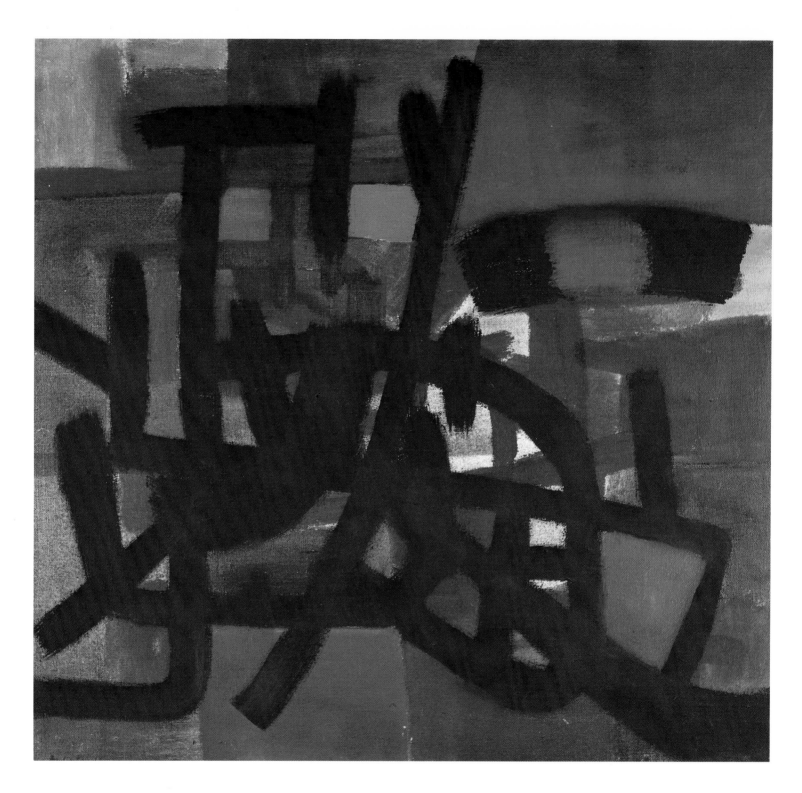

Fritz Winter

(born 1905) *Composition in Blue*, 1953, oil, 134 × 144.1 cm. Purchase, Museum Association Fund, 1965.54.

Fritz Winter was a student at the Dessau Bauhaus from 1927 until 1930 under Kandinsky, Klee, and Schlemmer. World War II and five stark years of forced labor in Siberia interrupted Winter's career, but he emerged after the war as one of the outstanding German abstract painters.

In *Composition in Blue* irregular geometric forms and calligraphic elements are seen against an ambiguous neutral field. According to Winter, the making of such images "arises from the desire to repeat the creation so that the artist can understand the universe through his own creation."

Max Beckmann

(1884–1950) *Self-Portrait in Tuxedo,* 1927, oil, 138.4 × 95.9 cm. Museum purchase, 1941.37.

 In this work, painted when Beckmann had reached the height of his artistic power, the artist appears like some mysterious and intimidating guest in the jaded world of Weimar Germany. The Berlin National Gallery bought the self-portrait in 1928, and it became one of the most celebrated of Beckmann's works at the time. But its fame in pre-war Germany was short-lived; it was one of the works purged from German museums during the Third Reich.

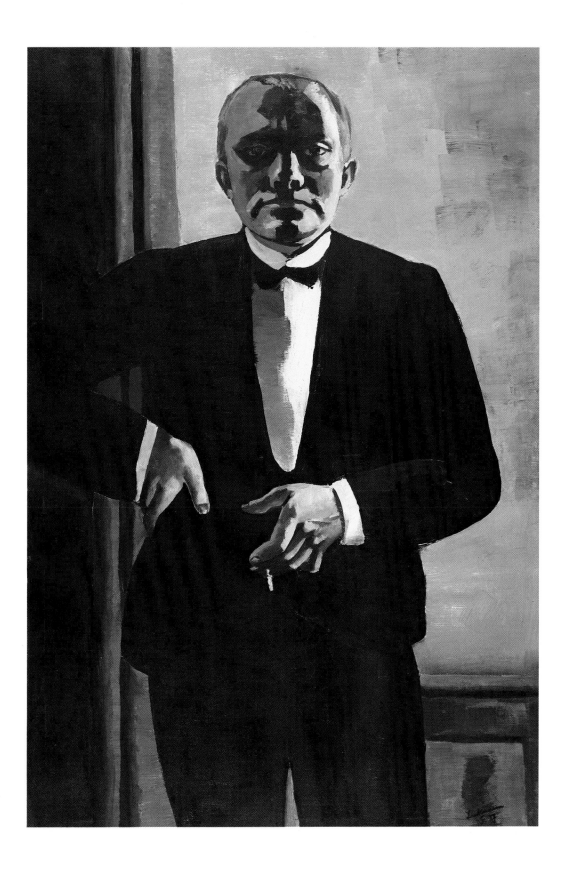

Max Beckmann

(1884–1950) *The Actors*, 1941–42, oil, center 199.4 × 150 cm., wings 199.4 × 83.7 cm. Gift, Mrs. Culver Orswell, Fogg Museum 1955.174 a-c.

 Beckmann painted this triptych while exiled in Holland. In it the artist depicts himself as the king in the center panel, thrusting a dagger into his breast. The theme of self-destruction reflects the tension and frustration of Beckmann's years in Amsterdam. After the Nazis invaded Holland, the artist continued to create monumental triptychs in secret, in a tobacco warehouse. The enigmatic, dreamlike figures depicted here are typical of other Beckmann triptychs. The artist's retreat into a mystical world enabled him to remain aloof from the events of the day, yet still creatively active. Beckmann's friend Stephen Lackner aptly characterized the artist's triptychs as "post-Christian altarpieces" and "three-act dramas."

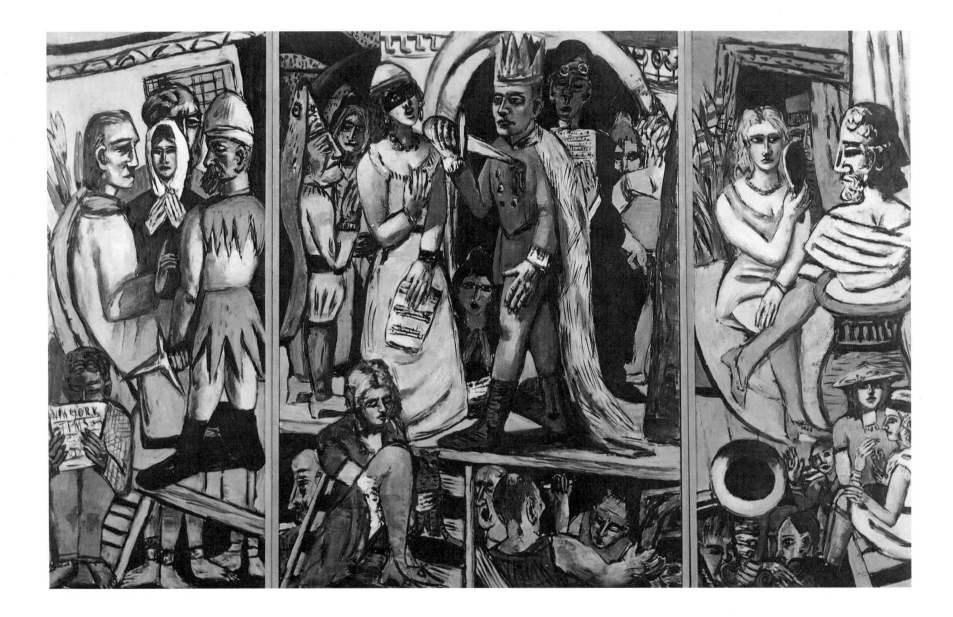

Paul Klee

(1879–1940) *Hot Pursuit*, 1939, colored paste and oil on paper on jute, 48.3 × 64.8 cm. Gift,
Mr. and Mrs. Alfred Jaretzki, Jr., Fogg Museum 1955.66.

 During the last years of his life, Klee was struck by scleroderma, a rare and fatal disease
which eroded his strength. Nevertheless, in 1939, the year before he died, Klee produced
1253 works, more than one-eighth of his total output; *Hot Pursuit* is one of these. In it he
expresses deep layers of consciousness undistorted by traditional visual formulas.

Kasimir Malevich

(1878–1935) *Composition*, c. 1915, oil, 43.1 × 30.7 cm. Alexander Dorner Trust, 1957.128.

Along with El Lissitzky, Kasimir Malevich was an innovative artist during the tumultuous years of the Russian Revolution. In December 1915 Malevich introduced his Suprematist works at the "Last Futuristic Exhibition of Pictures, 0.10." In his goal to achieve "pure" painting, Malevich reduced the formal elements in his art to the square, the rectangle, the triangle, and the circle. He painted these forms in primary colors and placed them in an undefined space. *Composition* is one of his earliest existing abstractions.

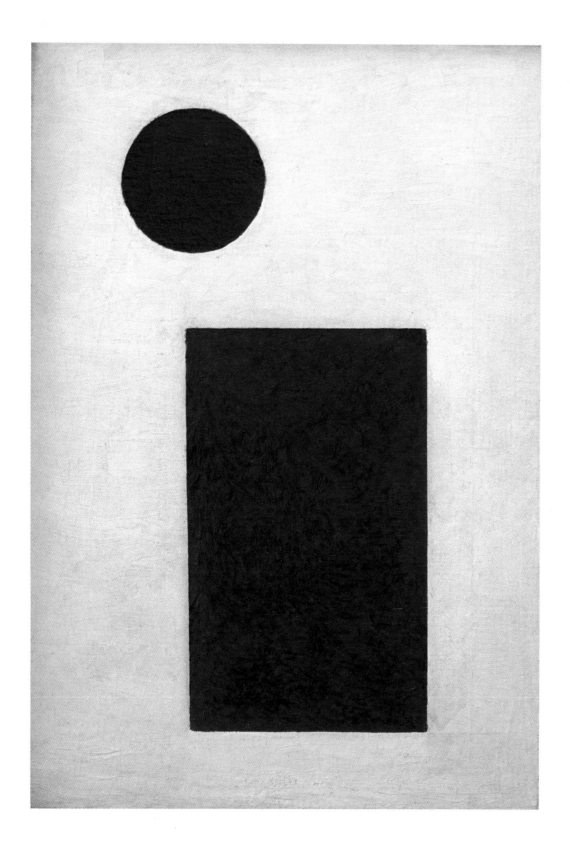

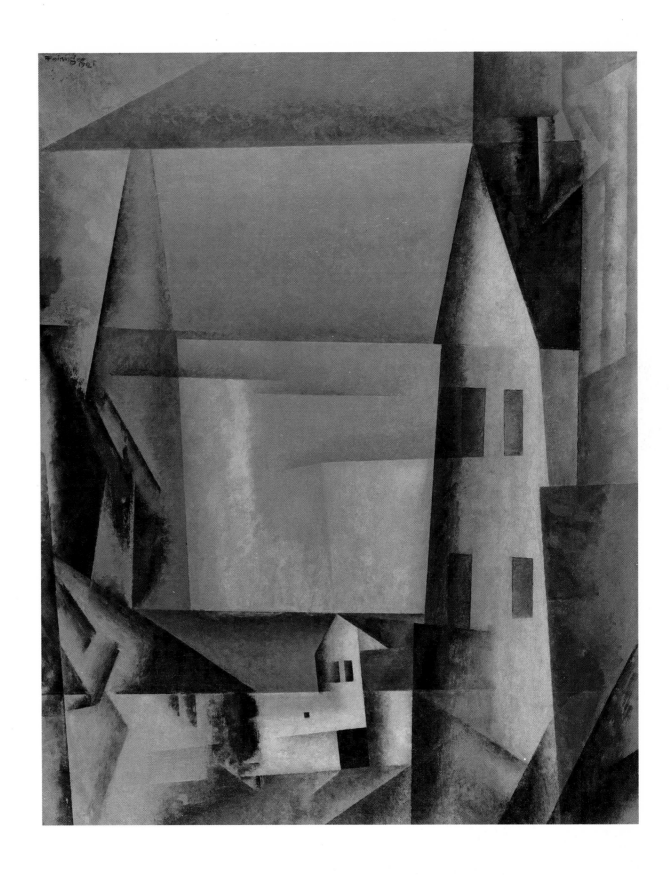

Lyonel Feininger

(1871–1956) *Gross-Kromsdorf III*, 1921, oil, 100 × 80 cm. Gift, Mrs. Julia Feininger, 1964.12.

Feininger was born in the United States and first went to Germany at the age of sixteen to study music. He remained in Germany for forty-eight years and returned to America in 1936. Feininger was the first artist Walter Gropius asked to join the Bauhaus faculty in 1919. This painting, in which planes and solid forms are rendered to make a harmonious vision of a medieval city, dates from the early years of that collaboration.

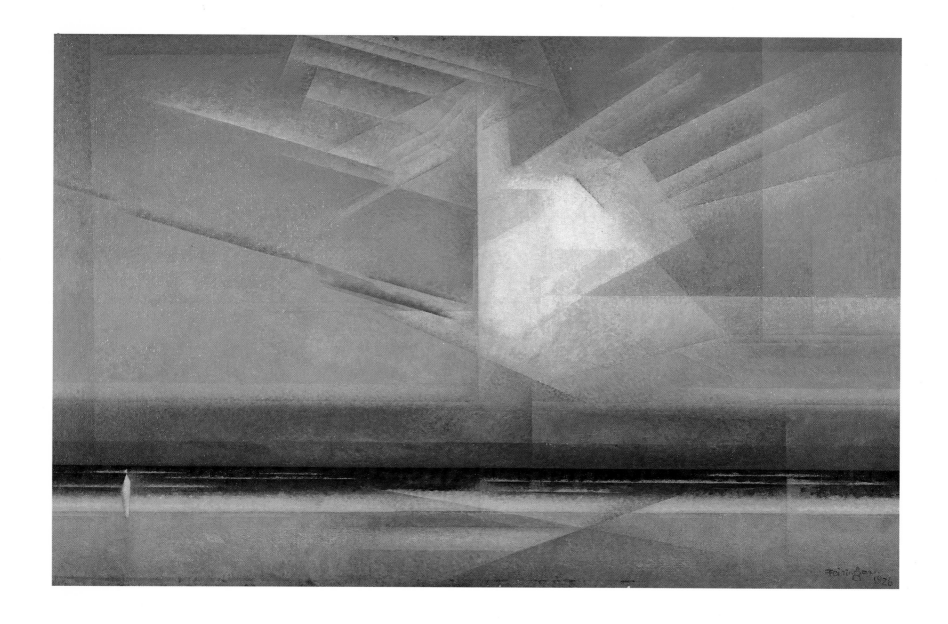

Lyonel Feininger

(1871–1956) *Bird Cloud,* 1926, oil, 43.8 × 71.1 cm. Museum purchase in memory of Eda K. Loeb, 1950.414.

Overlapping planes, some opaque and some transparent, mark Feininger's highly personal style. The birdlike cloud and sun-filled sky are created by iridescent shafts of luminous color. In the lower left-hand corner stands a quiet figure, a small shaft of white, perpendicular to the low, even horizon line of the sea. The Museum's Feininger Archive contains two watercolors and a number of drawings that are preparatory studies for this composition. One of the watercolors is reproduced on Page 115.

Wassily Kandinsky

(1866–1944) *Jocular Sounds,* 1929, oil on cardboard, 34.9 × 48.9 cm. Purchase, Museum Association Fund and in memory of Eda K. Loeb, 1956.54.

 As its title suggests, *Jocular Sounds* is a work of humor and wit. More importantly, however, it is a demonstration of Kandinsky's significant contribution to the esthetic theories of abstract art, and of his belief in the intrinsic power of points, lines, planes, and color to evoke emotion.

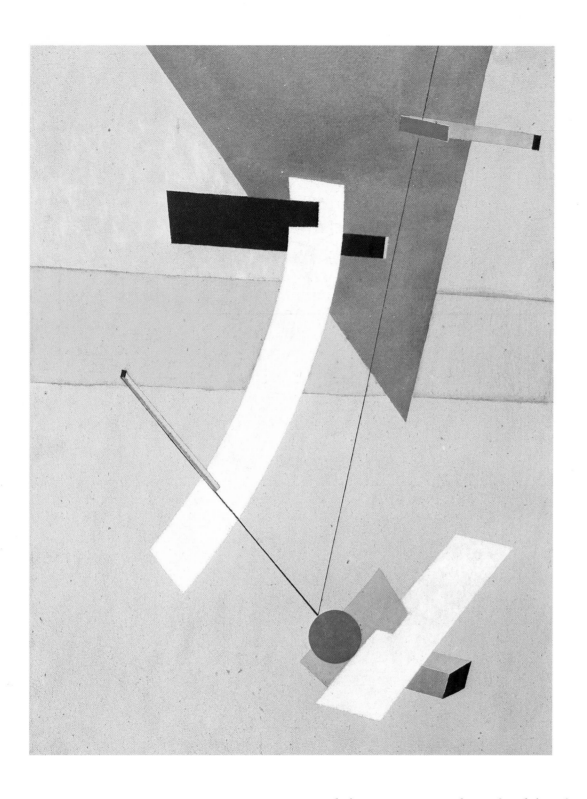

El (Lasar Markovitch) Lissitzky

(1890–1941) *Proun 12 E*, c. 1920, oil, 57.1 × 42.5 cm. Purchase, Museum Association Fund, 1949.303.

El Lissitzky was active during the years of upheaval in his native Russia at the time of the Revolution. He considered his art—particularly the development of a new visual vocabulary—as an important contribution to the building of a new society. He joined Tatlin's constructivist movement in 1919 and the same year painted his first constructivist composition, *Proun No. 1*. The PROUN series (Project for the Affirmation of a New Art) was perhaps his most influential contribution to twentieth-century art. El Lissitzky considered it an "interchange station between painting and architecture." The Busch-Reisinger *Proun 12E* of 1920 is a masterful composition of richly imaginative tensions and spatial ambiguities. It suggests the new technology of the twentieth century and the use of draftsmen's tools.

Laszlo Moholy-Nagy

(1895–1946) *A 18,* 1927, oil, 95.9 × 75.2 cm. Museum purchase, 1950.416.

Hungarian born Moholy-Nagy served on the Bauhaus faculty from 1923 to 1928. While his abstract painting owes a deep debt to Russian constructivist art, he went beyond the spare syntax of the constructivists to explore color and the organization of space by the use of transparent and translucent materials. A true abstractionist, Moholy-Nagy believed his paintings had no symbolic or representational associations. He titled his works with numbers and letters. In this case, "A" means that the painting is oil on canvas, not on a metal or synthetic surface.

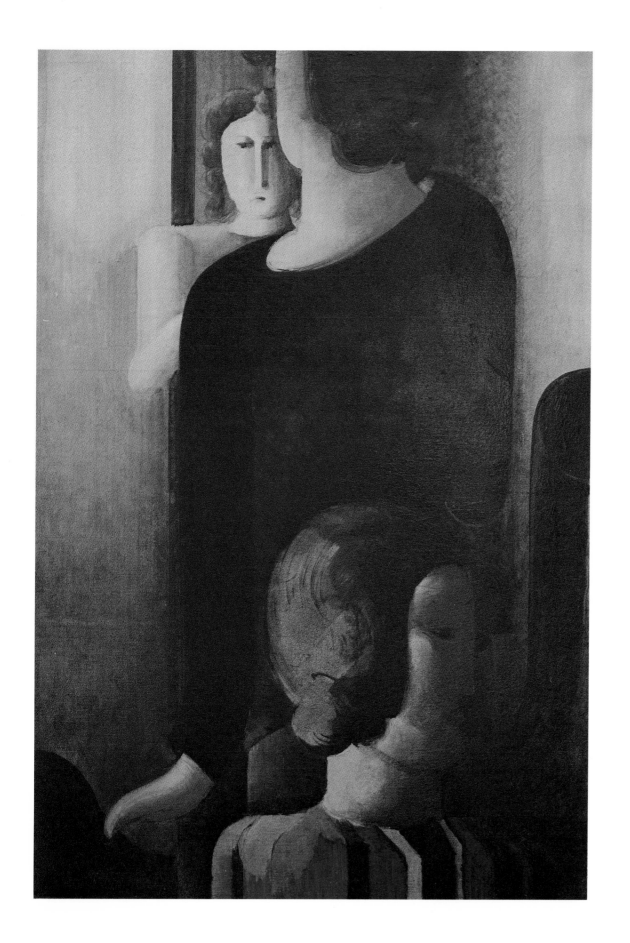

Oskar Schlemmer

(1888–1943) *Three Figures with Furniture-Like Forms,* 1929, oil, 90.9 × 60.3 cm. Gift, G. David Thompson, 1955.447.

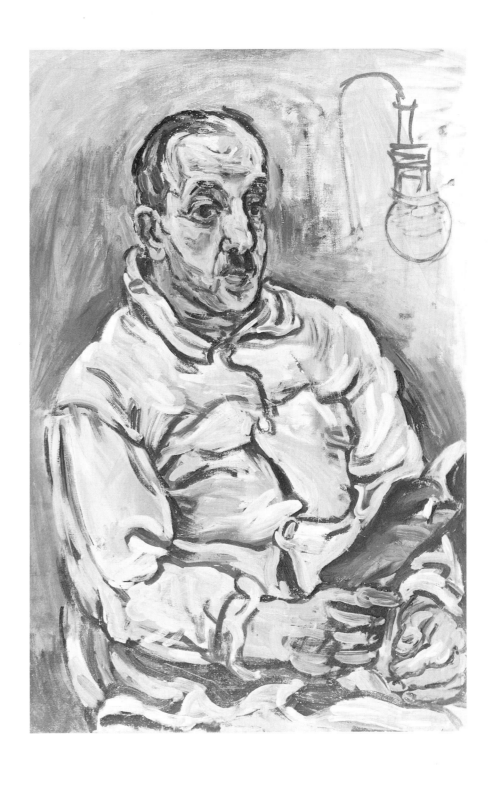

Oskar Kokoschka

(1886–1980) *Portrait of Dr. Heinrich von Neumann*, 1916, oil, 90.1 × 59.9 cm. Purchase, Museum Association Fund, 1952.21.

Soon after the outbreak of World War I, Kokoschka enlisted in the Austrian army. To buy a horse that would enable him to join an exclusive mounted unit, he sold his newly finished masterwork, *The Tempest,* now in the Kunstmuseum, Basel. The reality of combat shattered his romantic vision of himself as a dashing cavalryman. Shot in the head and bayonetted in one lung, Kokoschka returned to Vienna in 1916 to recuperate. He was treated by Heinrich von Neumann, an ear specialist. In his portrait of his doctor, Kokoschka shows his overwhelming interest in the psychological character of his sitter. Emphasizing the deeply set eyes and skilled hands, he has enclosed Neumann's sympathetically distorted features with a network of heavy outlines in a manner reminiscent of van Gogh's emotionally charged portrait of *Dr. Gachet.*

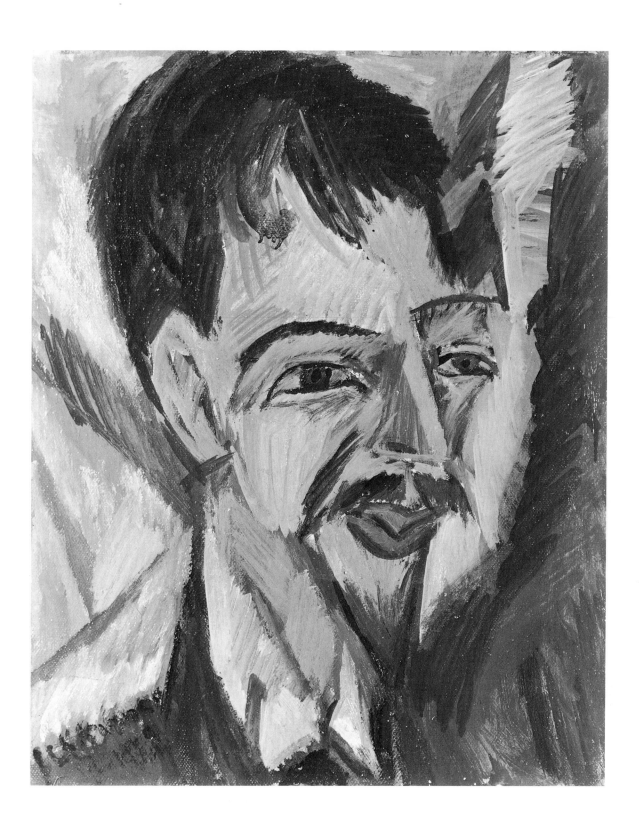

Ernst Ludwig Kirchner

(1880–1938) *Portrait of Alfred Döblin,* 1913, oil, 50.8 × 41.3 cm. Purchase, Museum Association Fund, 1951.44.

This work documents Kirchner's friendship with one of the emerging figures of the Berlin literary world, a writer best known today for his novel *Berlin Alexanderplatz.* In addition to this portrait, Kirchner also produced more than half a dozen drawings of Döblin, as well as a series of woodcuts illustrating the author's *Das Stiftsfräulein und der Tod.* The painting with its mat, liquid color, energized drawing, and aggressive angularity, is an excellent example of the artist's Berlin period.

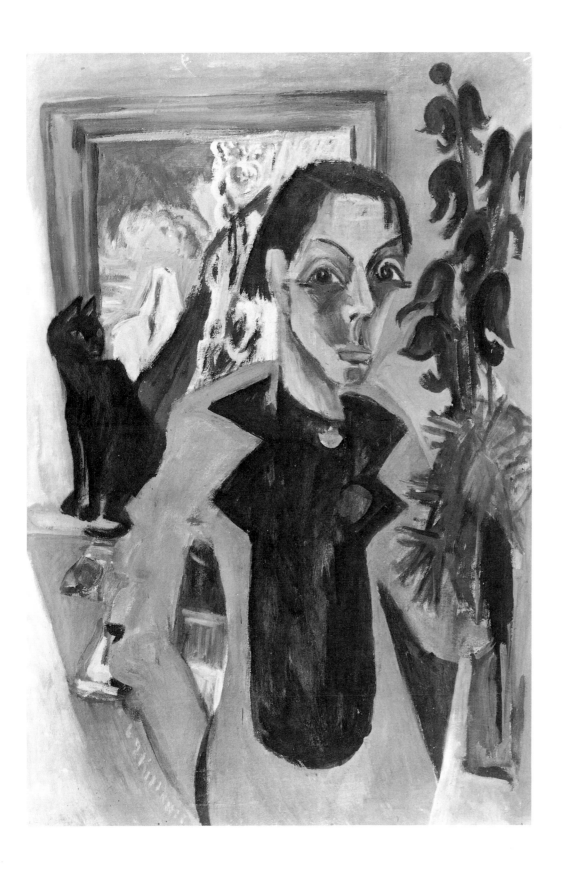

Ernst Ludwig Kirchner

(1880–1938) *Self-Portrait with a Cat,* 1920, oil, 120.6 × 80 cm. Museum purchase, 1950.12.
 After a harrowing experience as a soldier in World War I, Kirchner had a nervous breakdown and a bout with paralysis. This portrait is a pictorial document of his convalescence in Switzerland.

Emil Nolde

(1867–1956) *The Mulatto,* 1915, oil, 77.5 x 73 cm. Museum purchase, 1954.117.

As a young man Nolde had prayed that his art would become "vigorous, harsh and ardent." *The Mulatto* splendidly embodies these qualities. The emotionally charged image, the thickly smeared paint, and the vibrant color harmony dominated by incandescent reds and violets combine to create an effect of almost savage intensity. The painting was possibly inspired by Nolde's experiences on his journey to the South Seas in 1913–14.

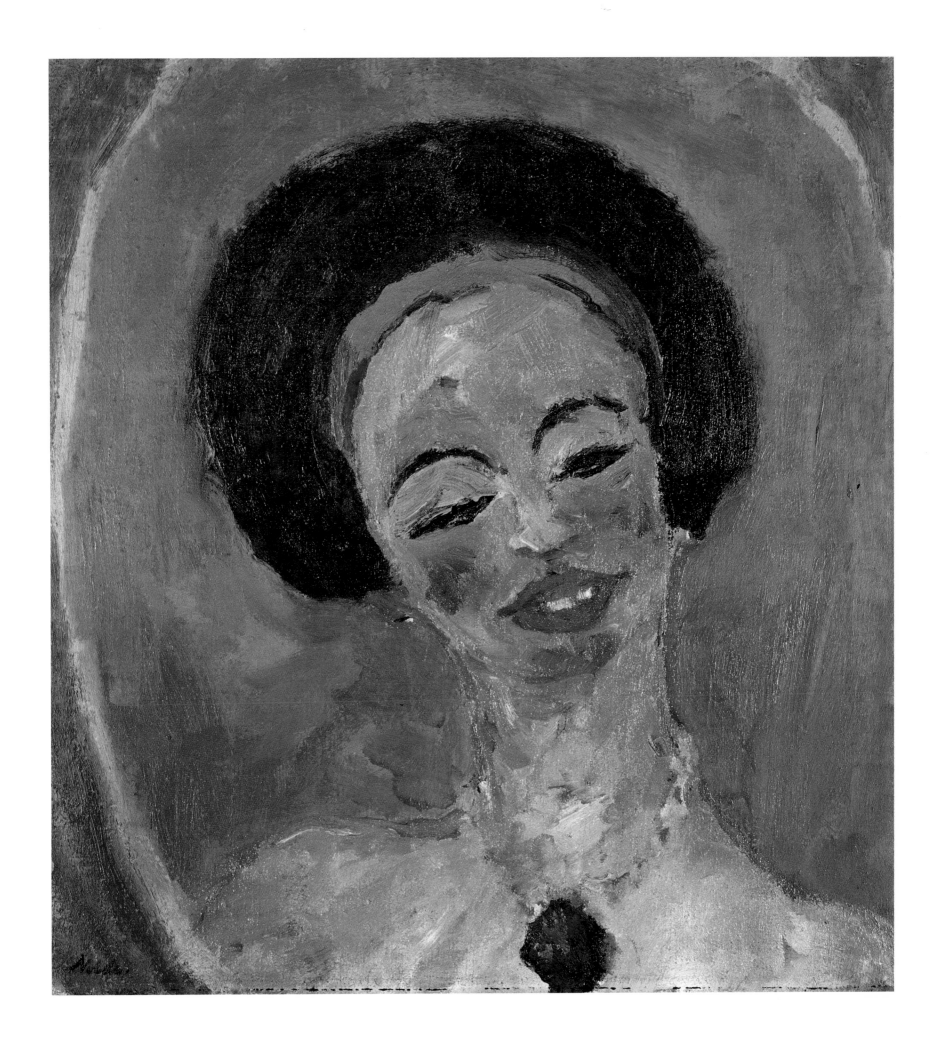

Karl Schmidt-Rottluff

(1884–1976) *Harbor Scene,* 1911, oil, 57.2 × 66.7 cm. Purchase, Museum Association and
Eda K. Loeb Funds, 1954.115.

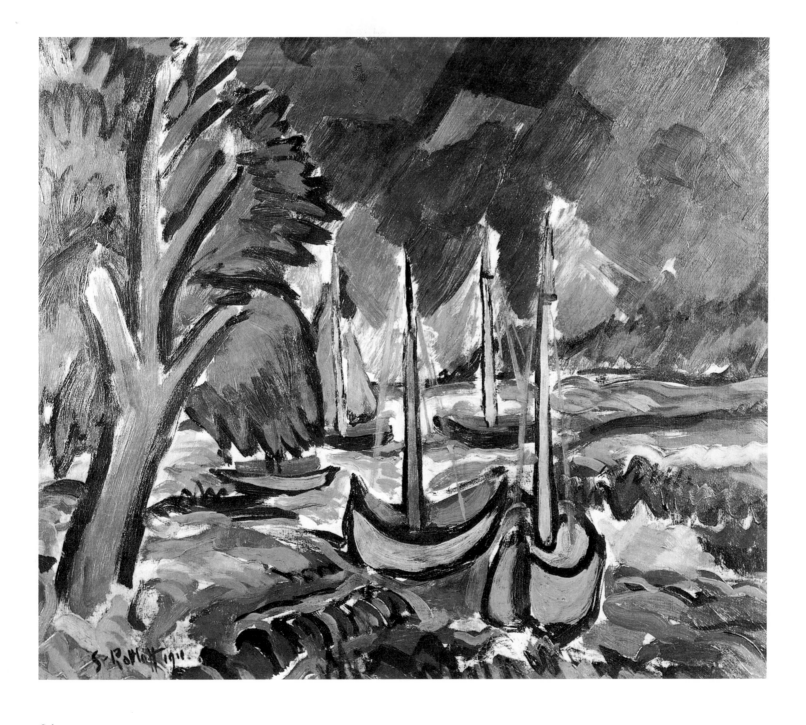

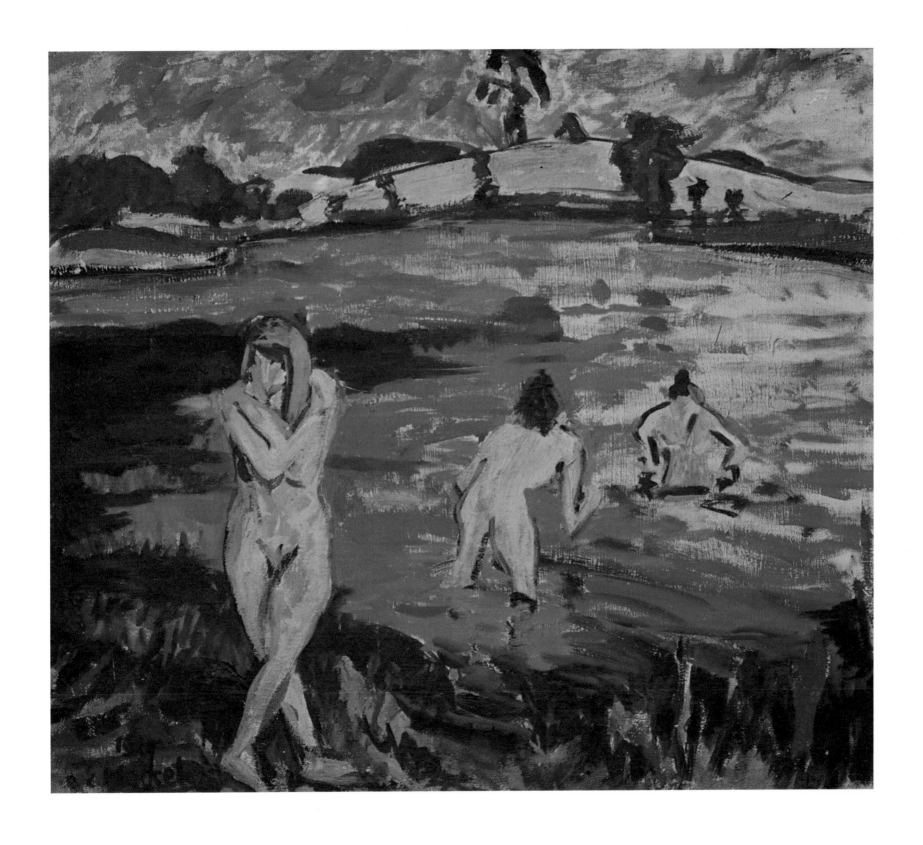

Erich Heckel

(1883–1970) *Landscape with Bathing Women*, 1910, oil, 98.4 × 83.8 cm. Museum purchase, 1950.430.

Erich Heckel

(1883–1970) *To the Convalescent Woman* (triptych, center panel), 1912–13, oil, 81.3 × 70.8 cm. Purchase, Edmee Busch Greenough Fund, 1950.415b.

One of the masterpieces of German expressionism, *To the Convalescent Woman* embodies some of the significant changes which occurred in Heckel's art after he moved from Dresden to Berlin in 1911. The intense, often saturated hues of the Dresden years have given way to subtler, richer harmonies, and line is used no longer merely as contour but is introduced as broad, vigorous hatch marks into the color areas. These stylistic developments coincide with a deepening of the emotional resonance in Heckel's work. This painting represents the artist's young wife Siddi surrounded (in the side panels) by flowers and the artist's own primitivizing wood carvings; in the background is an Ashanti wall hanging which Heckel's brother brought him from Africa.

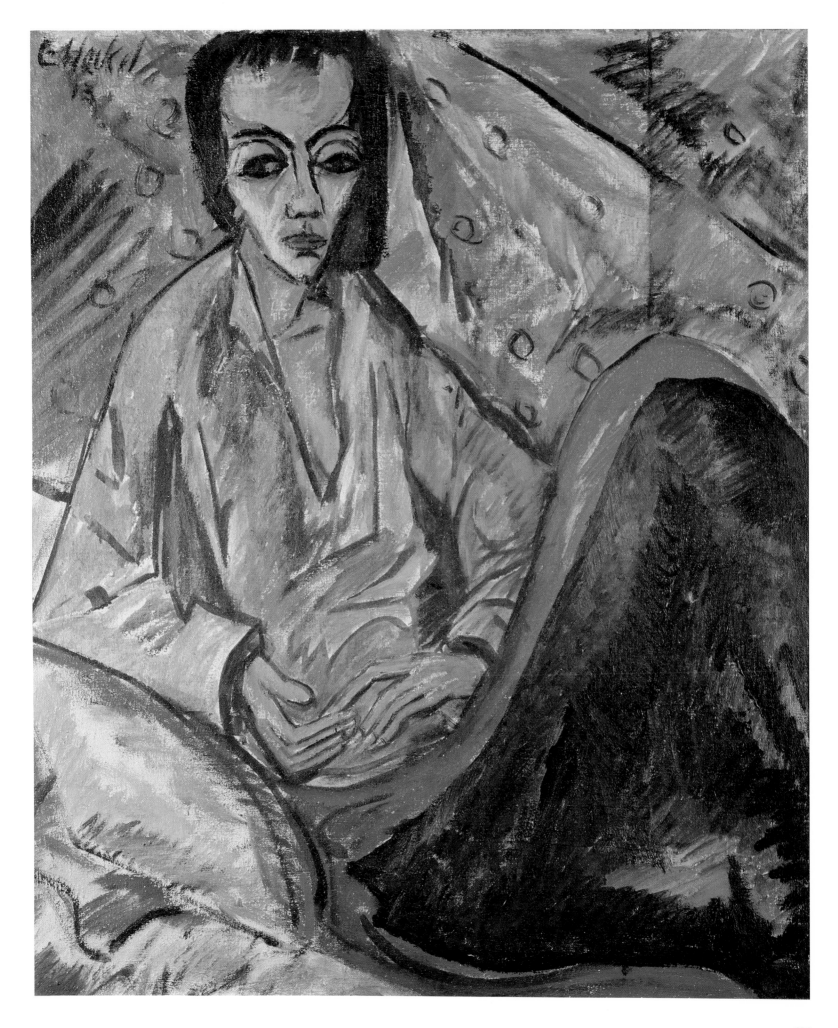

Alexei von Jawlensky

(1864–1941) *Head of a Woman,* c. 1911, oil on cardboard, 45 × 34 cm. Gift, Charles L. Kuhn, 1951.267.

Alexei Jawlensky, like Kandinsky, came from Russia to Germany where the two became long-lasting friends. Both were involved in founding the New Artists Association in Munich and later in collaborating with Feininger and Klee in the "Blue Four." Jawlensky's Russian heritage—particularly the forms and colors of icons and folk art—can be seen in his early work. His colorist sense echoes the Fauves' vibrant palette. The dominant motif of Jawlensky's painting was the head, usually a woman's head. Over the course of his career, these heads evolved from realistic versions to ethereal abstract compositions. In *Head of a Woman,* huge eyes with their direct gaze and the vivid colors contained in a black outline convey strong emotional expression.

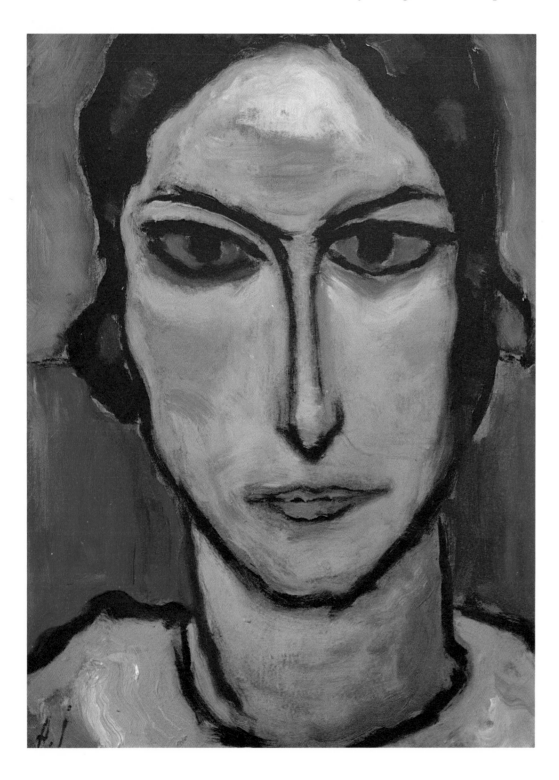

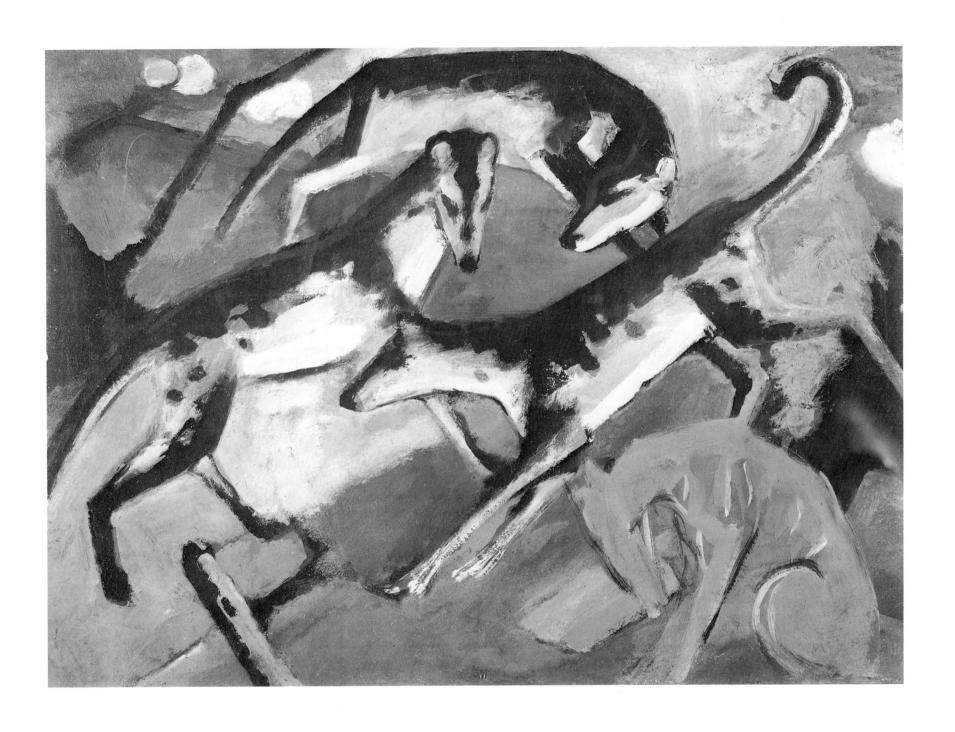

Franz Marc

(1880–1916) *Playing Dogs,* c. 1912, tempera, 38.1 × 54.6 cm. Museum purchase, 1950.451.

To Marc, animals expressed true innocence and were the embodiment of a cosmic rhythm. Through his work he not only attempted to suggest the beauty of their spirit, but tried to penetrate into their being in order to imagine their perception of the world. Marc was interested in the symbolism of color and used it to study animal life. In *Playing Dogs* he employs non-naturalistic colors and rhythmic forms to render an animated group of wild dogs. The dogs are placed in a landscape setting that repeats their shapes. Thus, nature and creatures are united spiritually and visually.

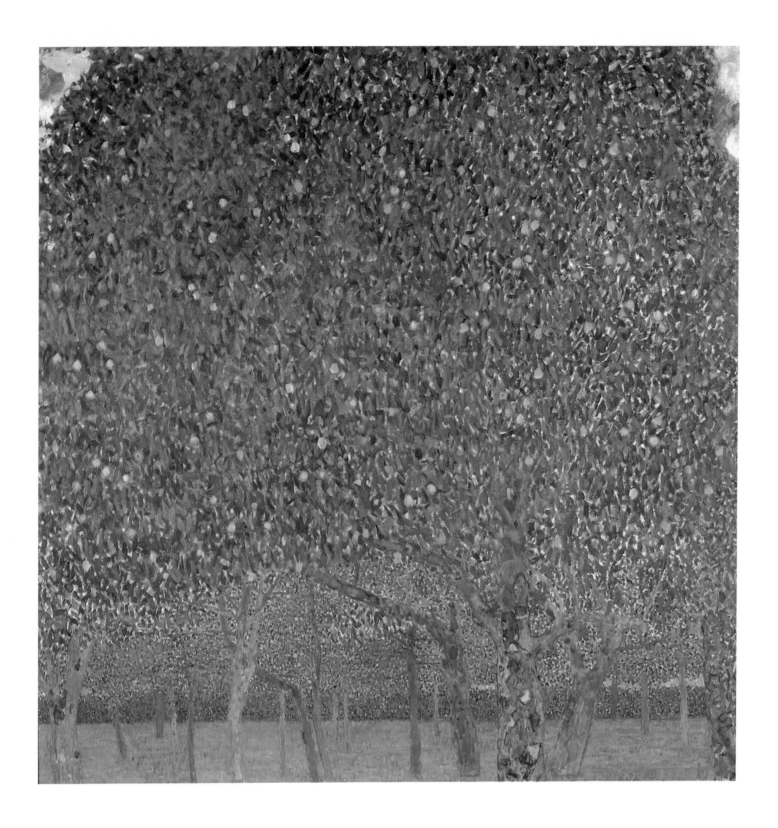

Gustav Klimt

(1862–1918) *Pear Tree,* 1903, oil and casein, 101 × 101 cm. Gift, Otto Kallir, 1966.4.

Klimt was the leading painter of the Vienna Secession. His highly individualistic style developed from his early training in mosaics, ceramics, and ornamentation, as well as a variety of other influences ranging from Greek vase painting, late Byzantine mosaics, and Japanese prints to impressionism and Jugendstil. Best known for his allegories and his decorative portraits of women, Klimt also began to paint landscapes after the turn of the century. *Pear Tree* is one of his earlier examples. Here, as in his figurative works, one finds a richly ornamented surface and a degree of spatial ambiguity.

Lovis Corinth

(1858–1925) *Salome,* 1899, oil, 76.2 × 83.3 cm. Gift, Hans H. A. Meyn, 1953.60.

Corinth was influenced by the French impressionists and romantics, particularly Delacroix. His opulent colors and robust forms also show a close affinity with the work of Rubens. Boldest of the German impressionists in the use of color, he nevertheless remained attached to traditional biblical and mythological themes. *Salome* of the Busch-Reisinger is a study for a more finished version of the same subject exhibited at the Berlin Secession in 1900, which is now in the Museum der bildenden Künste, Leipzig.

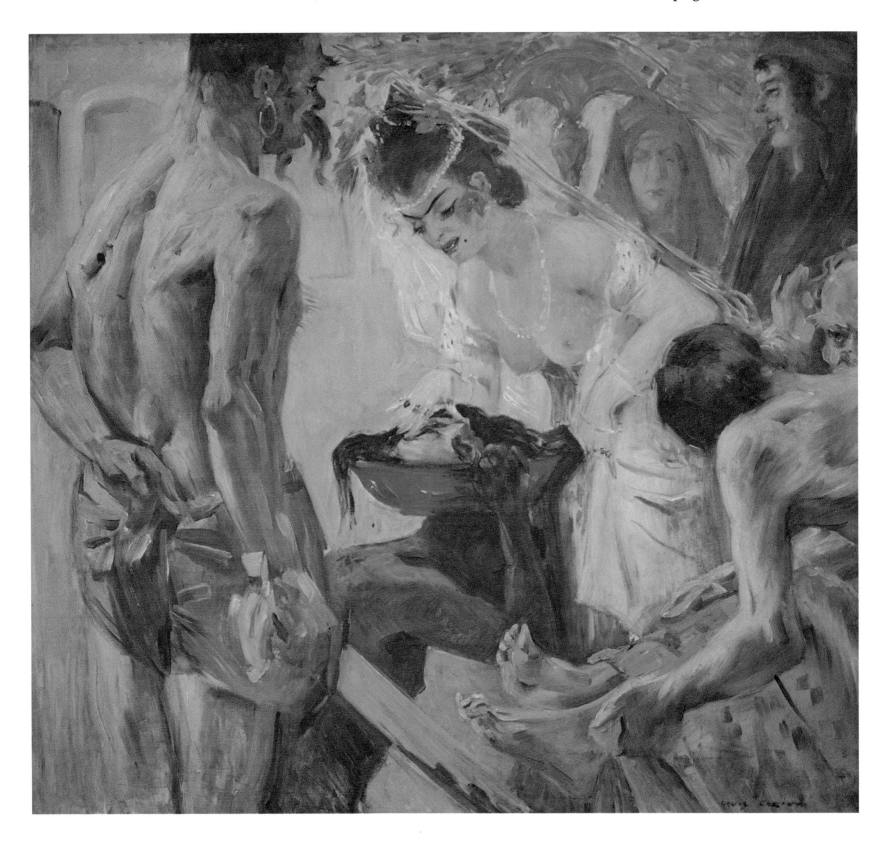

Edvard Munch

(1863–1944) *Rue de Rivoli,* 1891, oil, 79.7 × 64.5 cm. Gift, Rudolf Serkin, Fogg Museum 1963.153.

 Painted by Munch early in his career, during his sojourn in Paris, this picture predates the paintings concerned with eros and death characteristic of his maturity. Here Munch treats a theme associated with Monet and Pissarro, but whereas impressionist paintings of this motif celebrated the pleasurable spectacle of urban life, Munch's vision of the city has a grating intensity. The pale yellow and violet tones of the long facade form a harmony that speaks to the nerves as much as to the eye, and the pedestrians and carriages no longer seem to determine their own individual paths.

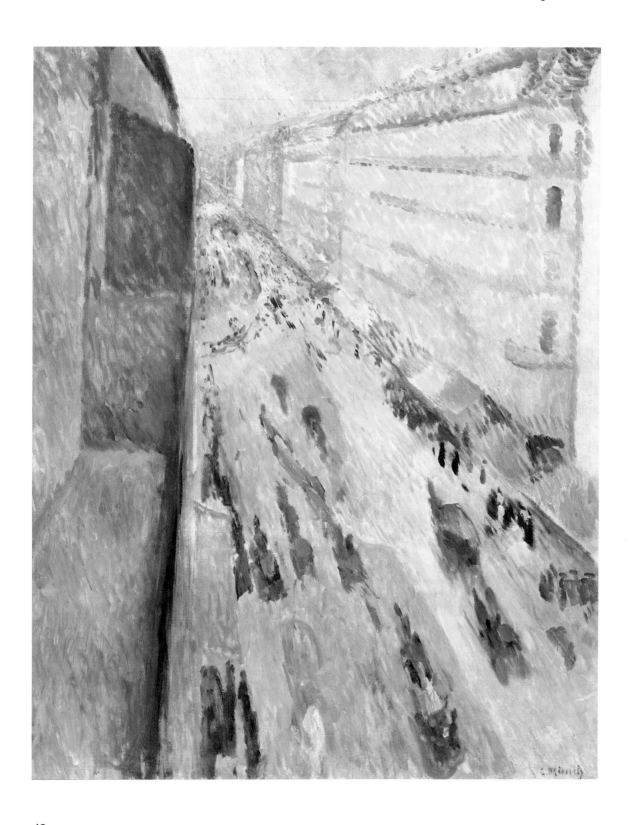

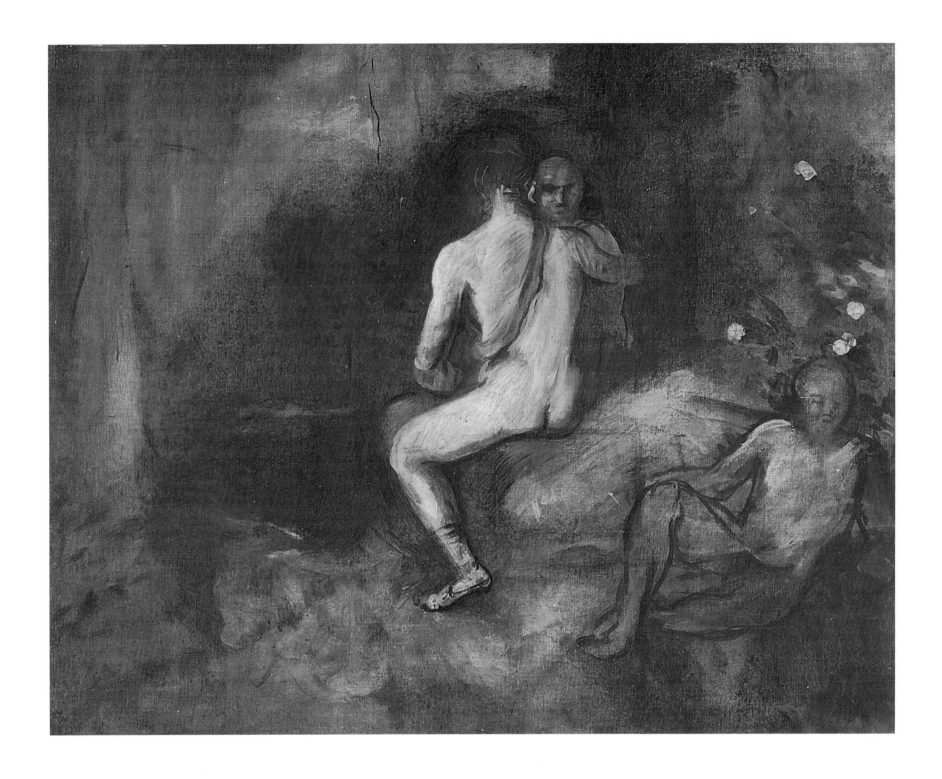

Hans von Marées

(1837–1887) *Forest Idyll,* c. 1870, oil, 60 × 76.2 cm. Gift, Erich O. and Kurt H. Grunebaum, 1960.31.

 Though little known in the United States, Hans von Marées was one of the most important, and also one of the most problematic, of nineteenth-century German artists who drew their chief inspiration from the art of classical antiquity and the Italian Renaissance. This painting, which Marées altered considerably, is probably the first of a series of sketches for *Evening Forest Scene. Forest Idyll,* along with another unfinished painting, *Landscape with Women,* which is also in the Busch-Reisinger Museum, are the only paintings by this important artist in any North American collection.

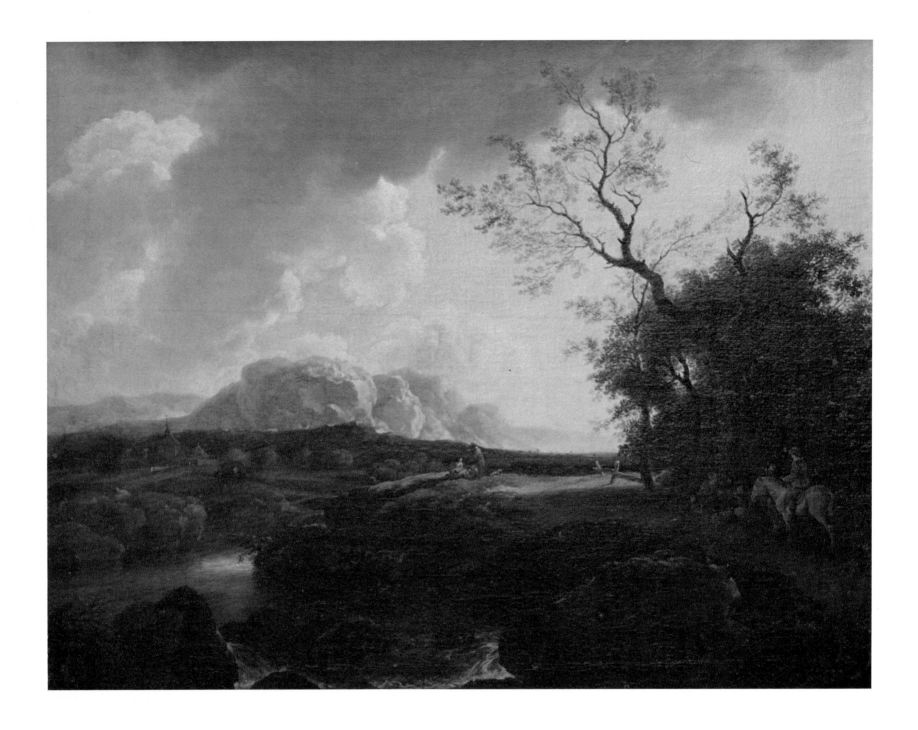

Ferdinand Kobell

(1740–1799) *Landscape with Travelers,* c. 1762, oil, 41.3 × 49 cm. Gift, Mr. and Mrs. Charles L. Kuhn, 1961.17.

Kobell began his career as a functionary in the court at Mannheim but soon abandoned it to become a painter. Most decisive for his subsequent development were the two years he spent in Paris studying with Johann Georg Wille who introduced him to seventeenth-century Dutch painting. Upon his return to Mannheim in 1771 he was appointed court landscape artist. His *Landscape* at the Museum is an early work that still shows evidence of his close study of the seventeenth-century Dutch landscapists who painted their native land as well as those who depicted scenes of the Italian countryside. His later landscapes, which show a more personal approach to nature, give a foretaste of nineteenth-century German realism.

Hans von Aachen

(1552–1616) *Venus and Adonis,* c. 1574–88, oil, 65.4 × 93.3 cm. Purchase, Friends of the Busch-Reisinger and anonymous funds, 1977.11.

 Hans von Aachen was one of the leading German painters of his time. He served as court painter to Emperor Rudolph II of Prague when this cosmopolitan court was one of the major European centers of artistic and scientific activity. *Venus and Adonis* probably dates from the artist's extended Italian sojourn (1574–88) and is arguably his earliest existing mythological painting. The work combines the elegant, attenuated figures popularized by Parmigianino with the rich colors and painterly approach characteristic of Venetian art.

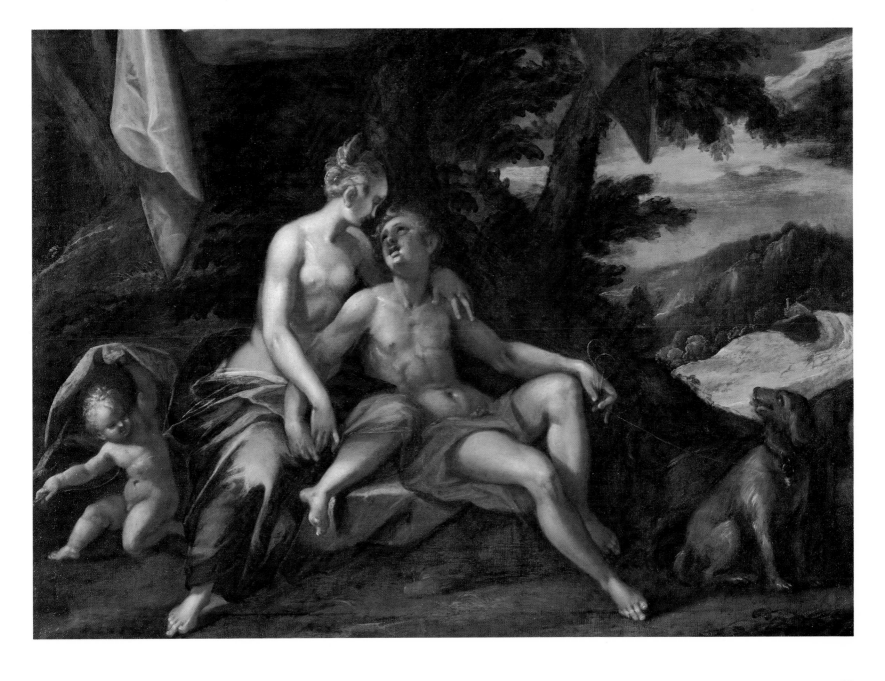

Attributed to **Joos van Cleve the Elder**

(c. 1470–1540, Flemish School) *Saint Jerome in His Study,* c. 1521, oil on panel, 99.7 × 83.8 cm. Gift, Howland Warren, Richard Warren, and Mrs. Grayson M.-P. Murphy, Fogg Museum, transferred to Busch-Reisinger Museum, 1965.17.

Saint Jerome (c. 342–420 A.D.) was the patron saint of humanists during the Renaissance in Northern Europe. One of the great scholars of the early Church, he translated the Bible from Hebrew and Greek into Latin. The Busch-Reisinger painting of Saint Jerome is a work of exceptional quality and interest. It is one of the numerous Flemish variants of Dürer's *Saint Jerome in His Study,* painted in Antwerp in 1521. Dürer's composition was copied by Joos van Cleve and was repeated in the Netherlands many times during the first half of the sixteenth century. The Busch *Saint Jerome* has been variously attributed to Joos, to Quentin Massys, and to members of their respective circles.

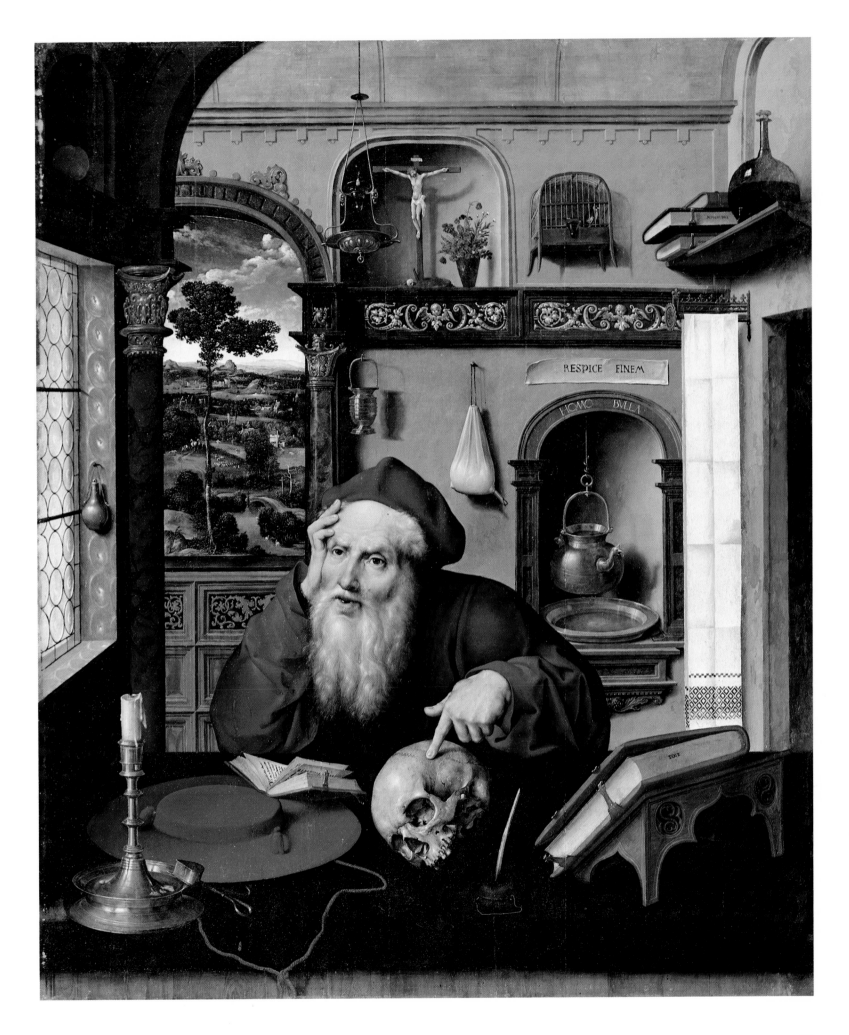

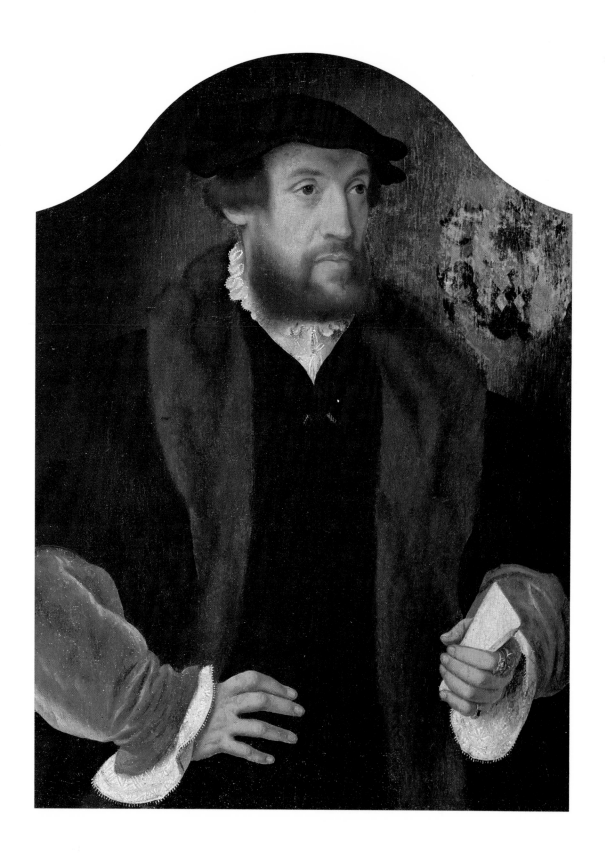

Barthel Bruyn the Elder

(1493–1555, German School) *Portrait of a Bearded Man,* oil on canvas (transferred from panel), 48.9 × 36.8 cm. Gift, Charles E. Dunlap, Fogg Museum, transferred to Busch-Reisinger Museum, 1966.36.

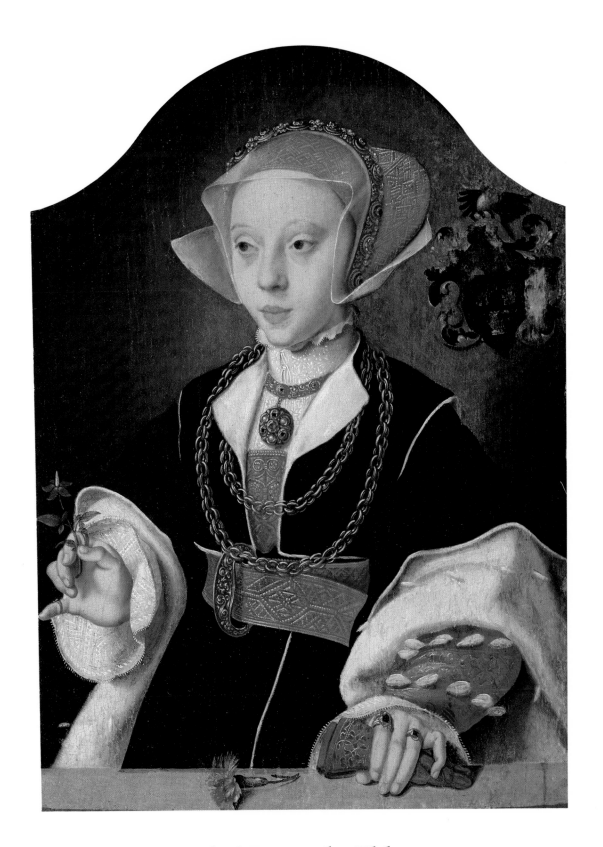

Barthel Bruyn the Elder

(1493–1555, German School) *Portrait of a Lady Holding a Flower,* oil on panel, 47 × 34.9 cm. Gift, Charles E. Dunlap, Fogg Museum, transferred to Busch-Reisinger Museum, 1966.37.

Barthel Bruyn was the leading portraitist of his generation in Cologne. The document held by the man probably indicates that he was a merchant or banker. A small carnation has been placed on the balustrade in front of the woman who holds the bloom of the deadly nightshade in her hand. Since a carnation alludes to bethrothal, and the nightshade to death, the flowers may indicate that the pair were man and wife and that the husband had died. The portraits show Barthel Bruyn's meticulous handling of detail and textures.

Jan Gossaert

(1470–1533, Flemish School) *Portrait of a Man Holding His Gloves,* oil on panel, 45.7 × 31.1 cm.
Gift, Arthur Sachs, Fogg Museum, transferred to Busch-Reisinger Museum, 1966.7.

 This portrait is characteristic of Gossaert's restrained early half-lengths. Later on he gives
his sitters a bit more elbow room, his backgrounds become more elaborate, and his forms
become more round and expansive. Gossaert moved in court circles and was highly thought
of by his contemporaries. Dürer, however, was not prodigal in his praise. He wrote that
Gossaert was better in execution than invention ("nit so gut im Hauptstreichen als im Gemäl").

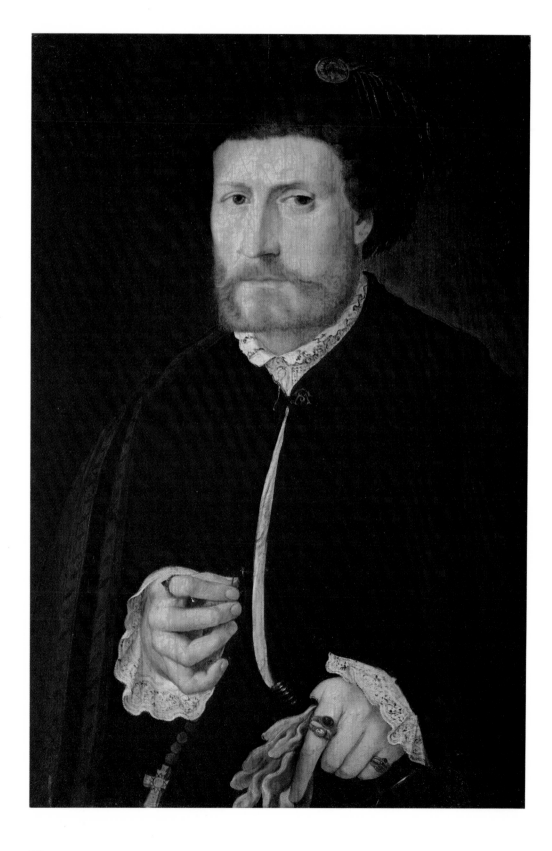

Rueland Frueauf the Elder

(Active 1470–1507, German School) *Visitation,* oil on panel, 69.2 × 40.6 cm. Museum purchase, 1965.52.

Rueland Frueauf was an Austrian painter who was active in Salzburg and Passau. Like many other fifteenth-century Austrian artists, he employed schemes invented by Netherlandish artists with great freedom and individuality. Frueauf's *Visitation* belongs to an altarpiece dedicated to the *Life of Mary* painted about 1495. Today some of its panels are untraceable and its existing ones are widely scattered: the *Annunciation* is at Budapest; the *Nativity* and *Presentation of Christ in the Temple* are at the Museo Civico Corror, Venice; the *Presentation of Mary* is in the Chapter House at Herzogenburg; and the *Death of Mary* is in the Chapter House at St. Florian.

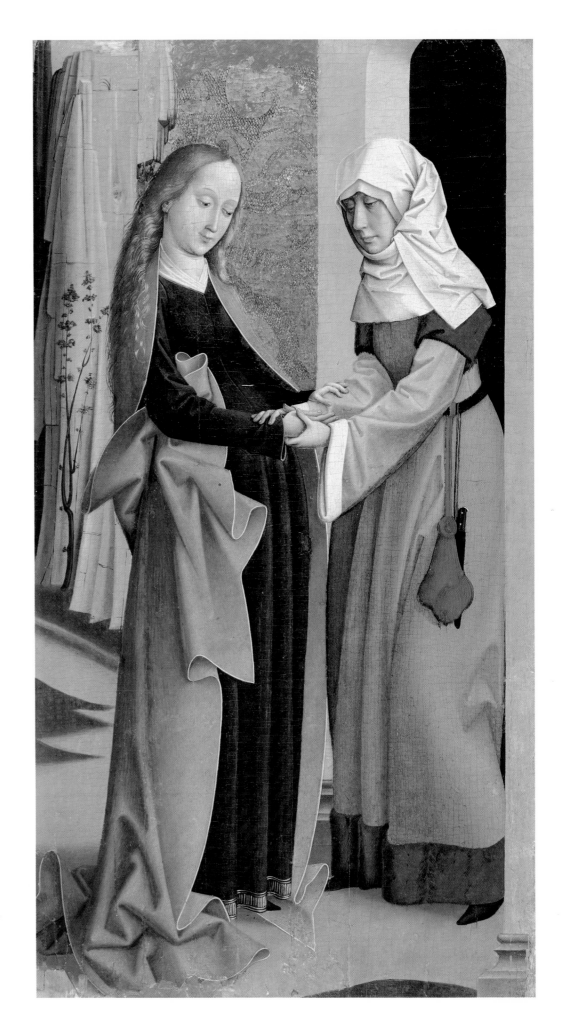

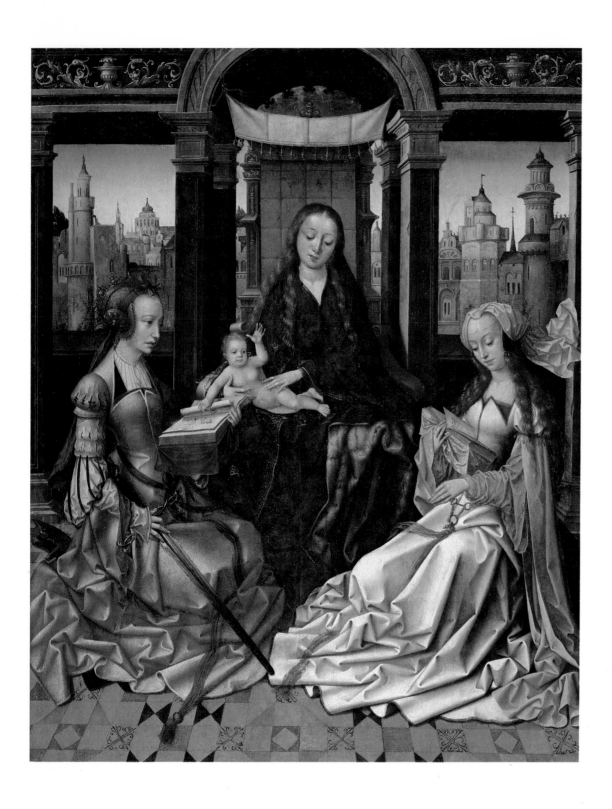

Antwerp School

Madonna and Child with Saints Catherine and Barbara, c. 1515, oil on panel, 85.1 × 61 cm. Gift, Mrs. Felix M. Warburg in honor of her husband, 1941.36.

The painting is attributed to an anonymous Antwerp artist on the basis of its close resemblance to one formerly in the Hoe collection, New York, by Goswin van der Weyden, a painter active in Antwerp during the first decades of the sixteenth century. The symmetrical arrangement of the figures, their calm repose, and the flattened space they occupy reflect the archaizing trend that enjoyed a vogue in Antwerp during these years. Only in the tension shown in the face of St. Catherine and in the fluttering headdress and partly raised arm of St. Barbara are there hints of the restlessness characteristic of the new style introduced to the Netherlands during these decades by the Antwerp Mannerists.

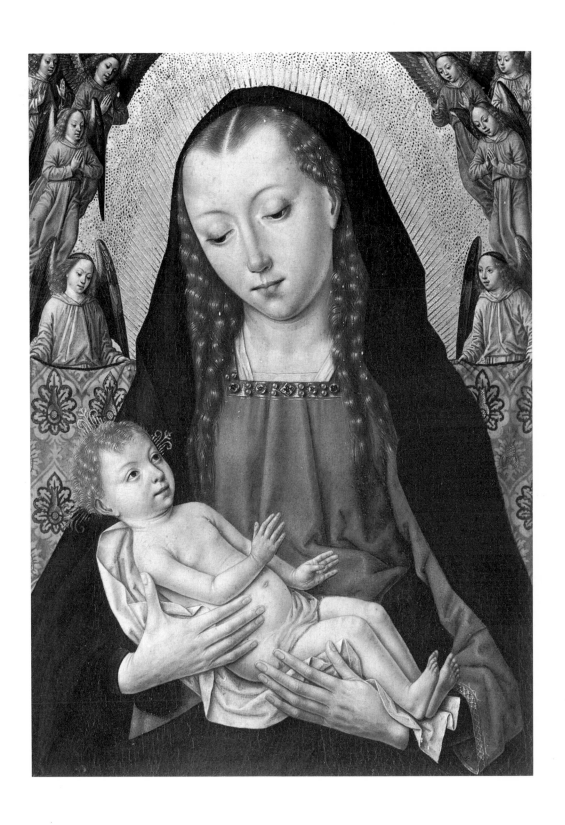

Master of the St. Ursula Legend

(c. 1460–1500, Flemish School) *Madonna and Child,* c. 1490, oil on panel, 41.3 × 29.5 cm.
Bequest, Grenville L. Winthrop, Fogg Museum, transferred to Busch-Reisinger Museum,
1965.23.

The anonymous artist known as the Master of the St. Ursula Legend is named after an
altarpiece, now in Bruges, which shows scenes from the legendary life of the saint. Most of
the works attributed to him are closely related to those done by Memling, but in the present
picture he chose Roger van der Weyden as his model. The panel was probably intended as
the left wing of a diptych; the Master's *Portrait of a Man* (Ludovico Portinari?), now in the
Johnson Collection, Philadelphia, may have been the other part of the diptych.

Follower of **Lucas van Leyden**

(Dutch School) *Angel,* c. 1530, oil on panel, 35.6 × 27.3 cm. Bequest, Grenville L. Winthrop, Fogg Museum, transferred to Busch-Reisinger Museum, 1965.24.

 This painting, done by an unidentified artist who was closely familiar with Lucas's pictorial achievement, especially his luminous daylight effects, is a fragment of a larger painting, most likely of the nativity of Christ.

Follower of **Roger van der Weyden**

Madonna and Child (left panel).

Follower of **Gerard David**

Portrait of Joos van der Burch with Bishop St. Jodoc (right panel)
(Flemish School, c. 1475–1525) Oil on panel, each panel 54.8 × 34.7 cm. Bequest, G. W.
Harris in memory of John A. Harris, Fogg Museum, transferred to Busch-Reisinger
Museum, 1965.22.

 The left panel of this diptych was done by an anonymous follower of Roger van der
Weyden, who derived his devotional image from Roger's most popular composition: the
Virgin as she appears nursing the Child in his *Saint Luke Painting the Virgin,* which is now in
the Museum of Fine Arts, Boston. Numerous variants of this composition exist and it is
highly unlikely that the artist based his version on the original in Boston. The right panel
was painted by a member of Gerard David's studio. It shows the donor Joos van der Burch,
with his hands held in prayer, presented by a bishop. Since many paintings similar to the
left one exist, they may have been mass produced and kept in stock, ready to be paired with
a commissioned donor portrait.

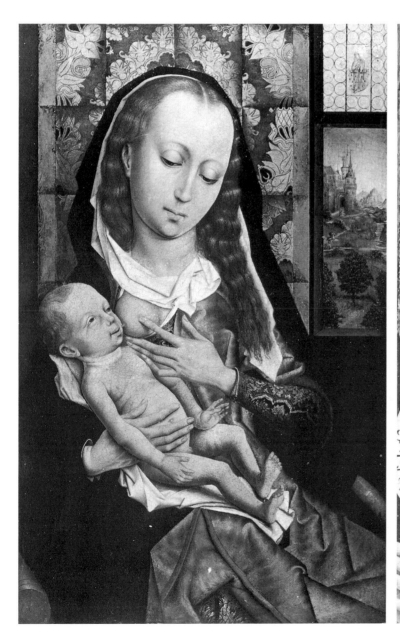

Dirck Bouts

(c. 1420–1475, Flemish School) *Madonna and Child,* oil on panel, 29.7 × 21.7 cm. Gift, Mrs. Jesse Isador Straus in memory of her husband, Jesse Isador Straus, class of 1893, 1959.186.

This small devotional image of the Virgin mothering her child is derived from a type popularized by Roger van der Weyden, but the special combination of firmness and softness of the figures as well as the particular attention given to light are personal characteristics of Bouts's style. His Madonnas at half-length are rare. Apart from the one at the Museum, Max J. Friedländer accepted only three others as by the master's own hand; they are at the National Gallery, London, at the Bargello in Florence, and in the Staedel, Frankfurt. Infrared photography has revealed that there is a much rarer study beneath the visible paint surface of the picture: a full-length female nude. No painting of a single female nude by Bouts is known and only a couple by other fifteenth-century Netherlandish artists have been identified. We can only guess why Bouts abandoned his original project.

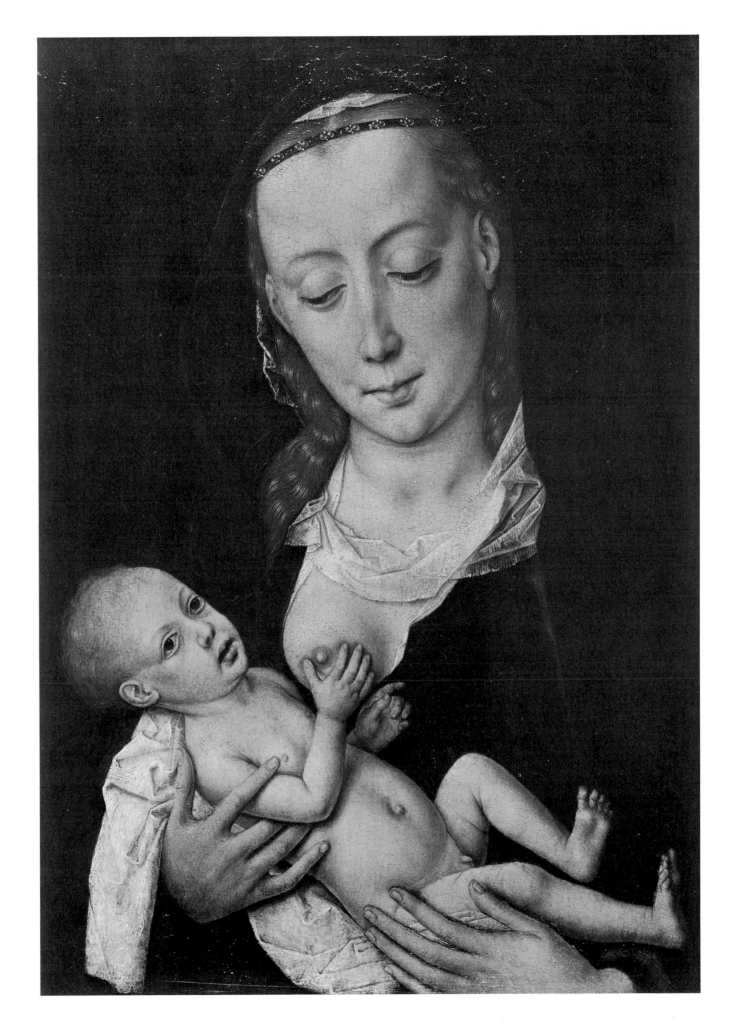

SCULPTURE

Laszlo Moholy-Nagy

(1895–1946) *Light-Space Modulator*, 1923–30, h. 151.1 cm. Gift, Sibyl Moholy-Nagy, 1956.5.

Moholy-Nagy pioneered in the creation of light-and-motion machines built from reflecting metals and transparent plastics. He named them "light modulators."

Between 1922 and 1930 Moholy-Nagy, with the aid of an expert mechanic, designed and built the *Light-Space Modulator*, an apparatus of moving aluminum and chrome-plated surfaces driven by an electric motor and a series of chain belts. To achieve its full effect, the machine must be seen in a darkened room, with spotlights alternately thrown upon its turning parts. It varied both shadow and substance, and gave form to Moholy's belief that light, if rendered into art, must first be transmitted and transformed through materials —not projected directly at the viewer. The result is a myriad of shifting and dissolving shadows passing over walls and ceiling. Moholy recorded the complex effects the machine achieved in a film which is now in the Museum's collection.

The *Light-Space Modulator* was one of the boldest and most imaginative creations that stemmed from the wedding of art with modern technology. It became the archetype for the new medium of kinetic art.

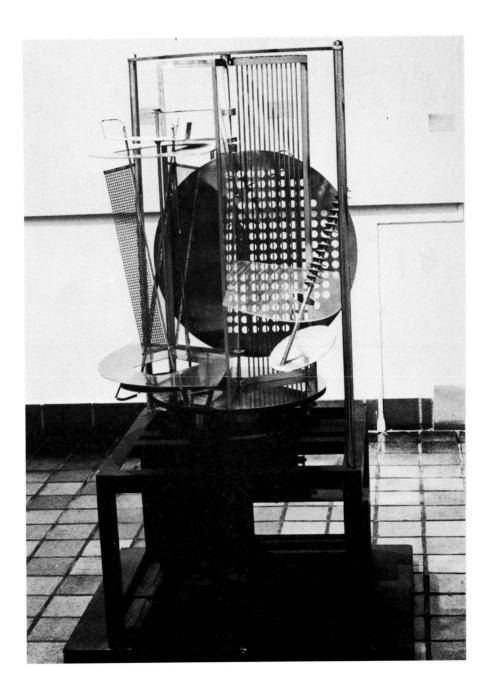

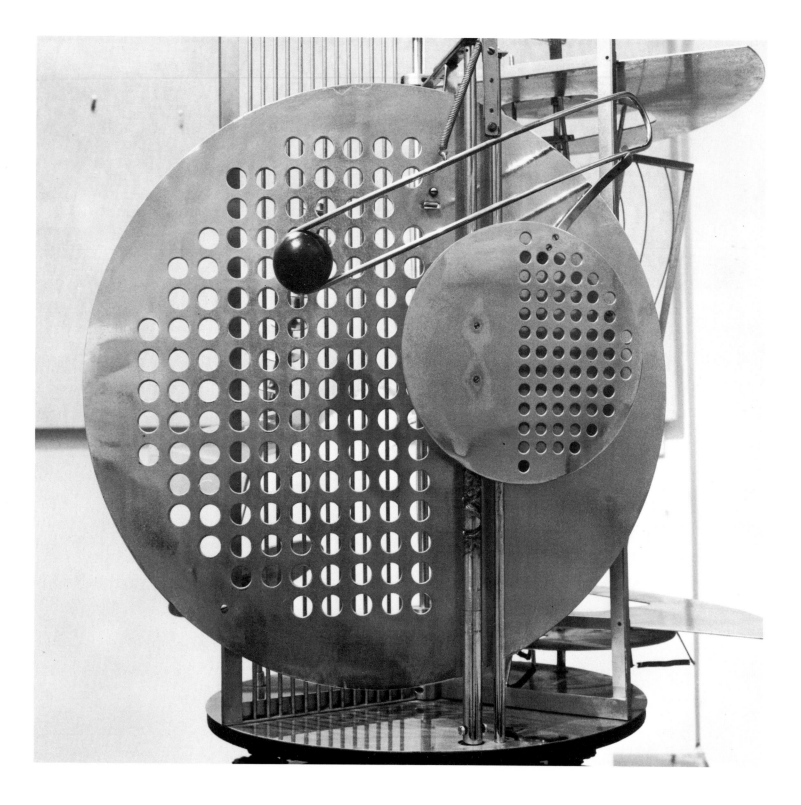

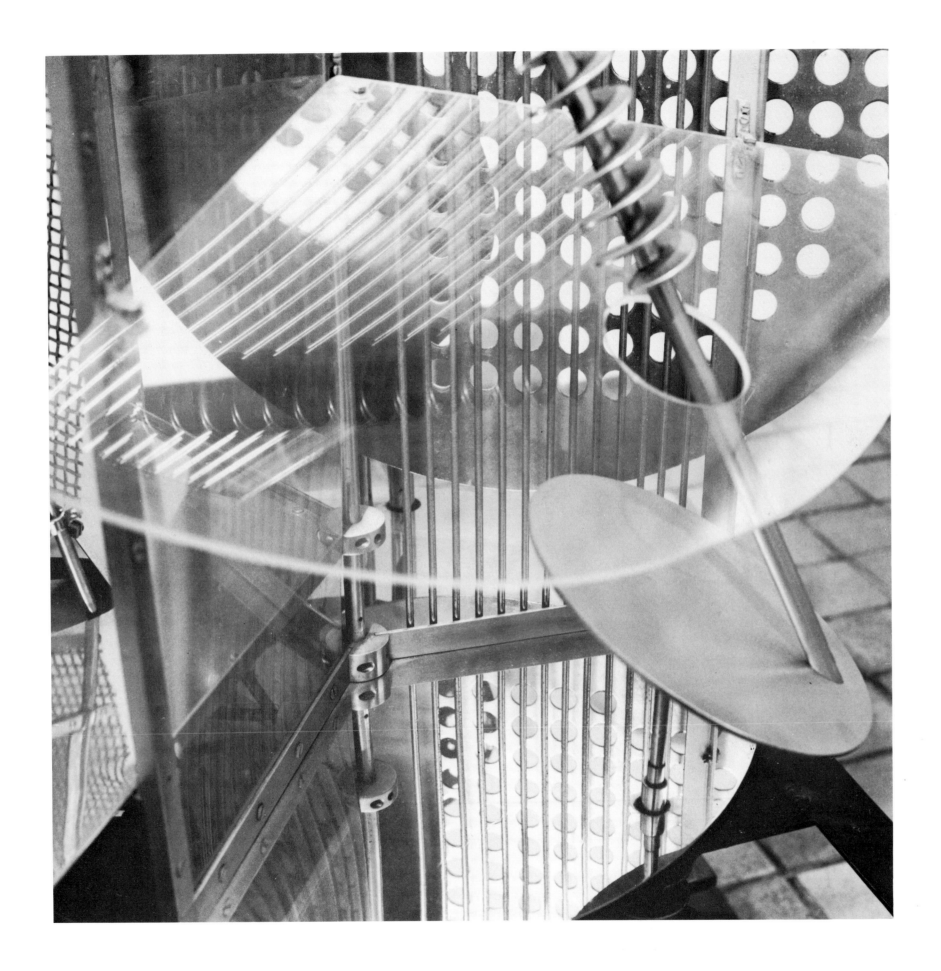

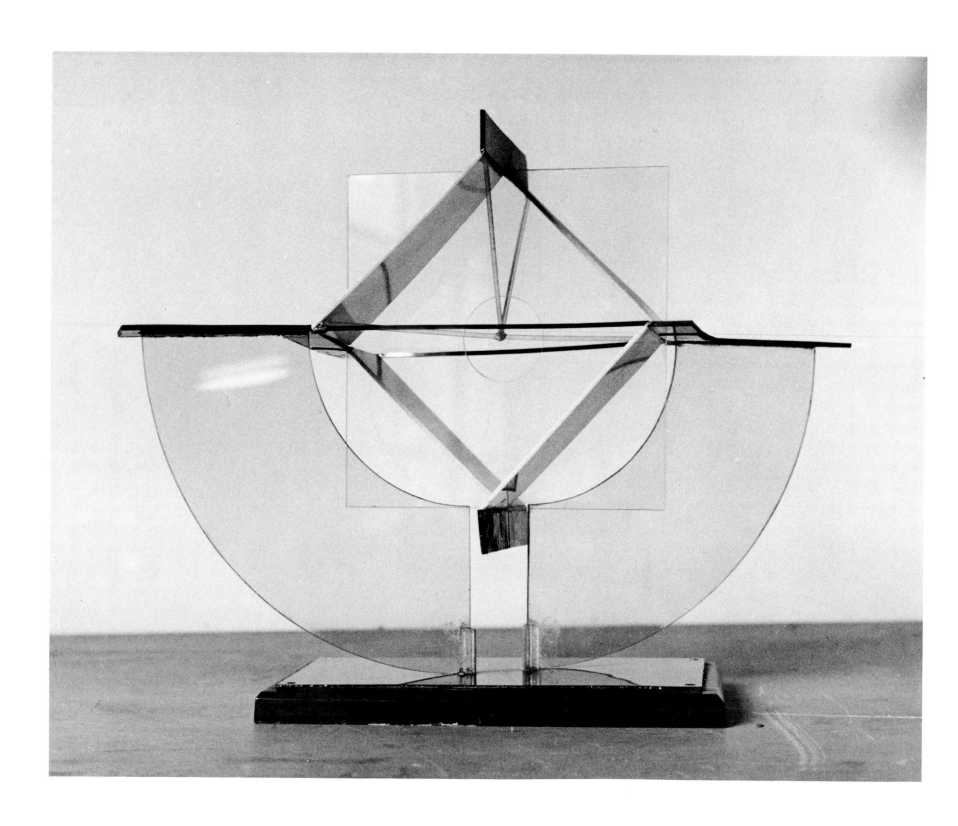

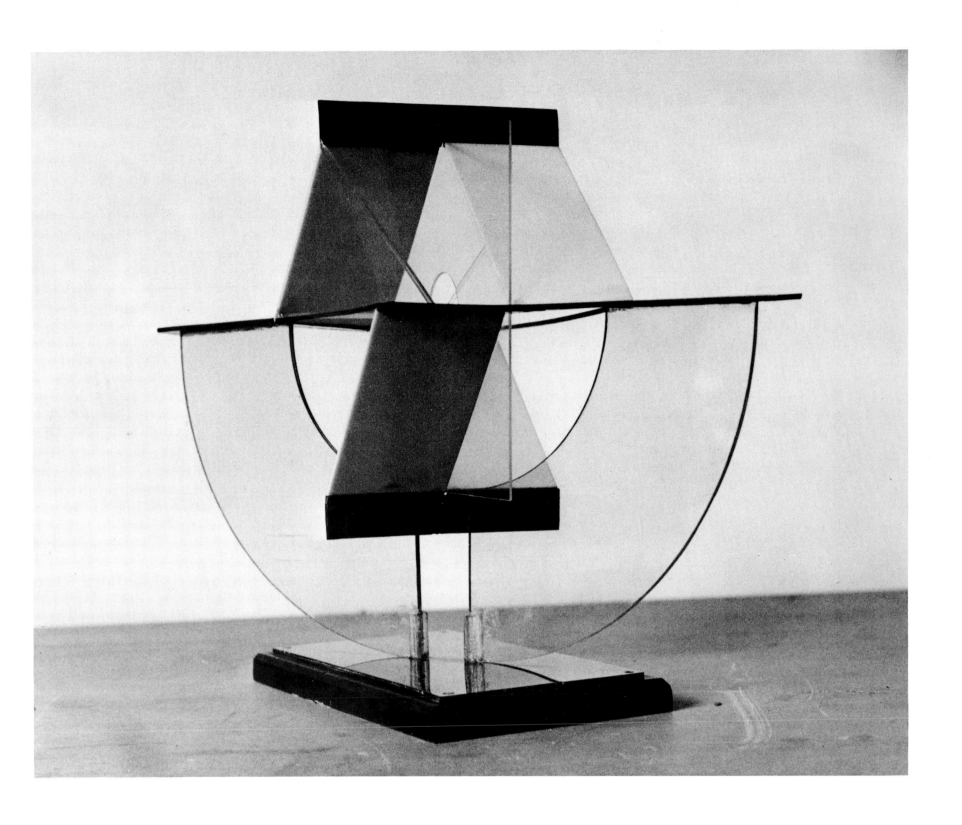

Naum Gabo

(1890–1977) *Construction in Space with Balance on Two Points*, 1925, black, white, and transparent plastics, h. 25.6 cm. Gift, Lydia Dorner in memory of Dr. Alexander Dorner, 1958.46.

Gabo's constructivist art reflects his interest in physics, engineering, and new synthetic materials. For him, sculpture was not a shaping of volumetric, monolithic masses but an articulation of space by means of thin, often transparent planes; space does not merely surround sculptural form but is an essential component of it. This small, delicately balanced construction epitomizes the qualities that make Gabo one of the seminal figures of modern sculpture.

Gerhard Marcks

(born 1889) *Prometheus II*, 1948, bronze, h. 78.1 cm. Museum purchase, 1952.17.

Marcks taught sculpture and pottery at the Weimar Bauhaus and then was on the faculty of the Halle School of Arts and Crafts. Until he visited Greece in 1928, his works showed the strong influence of Barlach's heavily draped figures. After this trip the nude figure became his principal subject. His *Prometheus* shows the god bound, a price humanity's great benefactor had to pay for stealing fire from Olympus and giving it to man. The sculpture, which was made soon after World War II, embodies the painful frailty of man as well as the suffering of a classical hero.

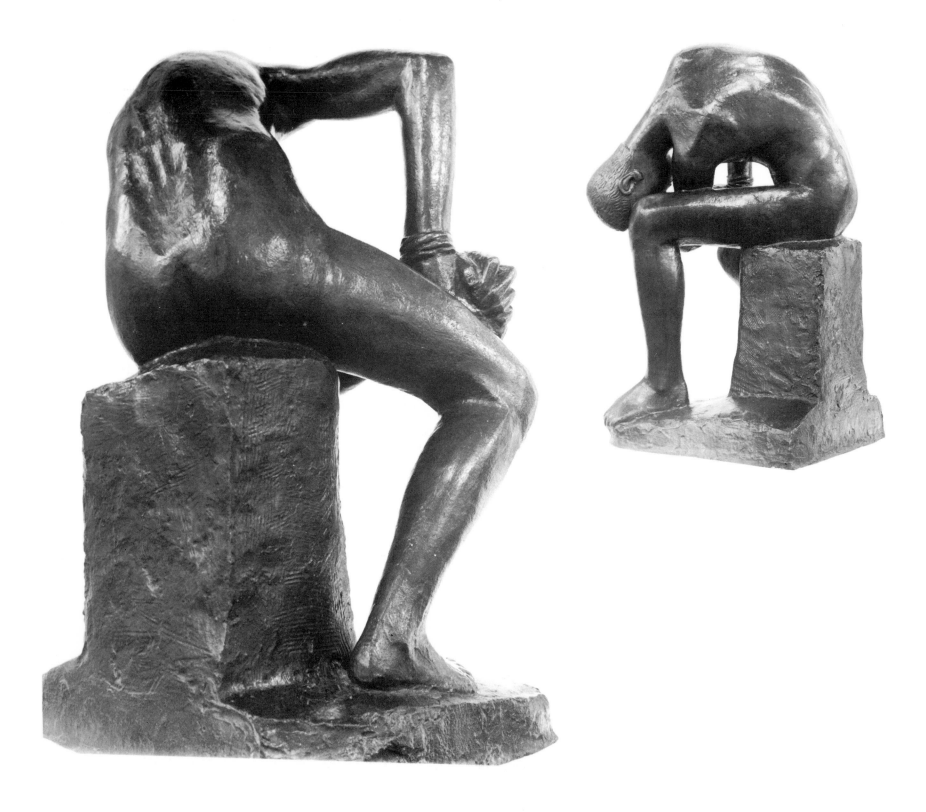

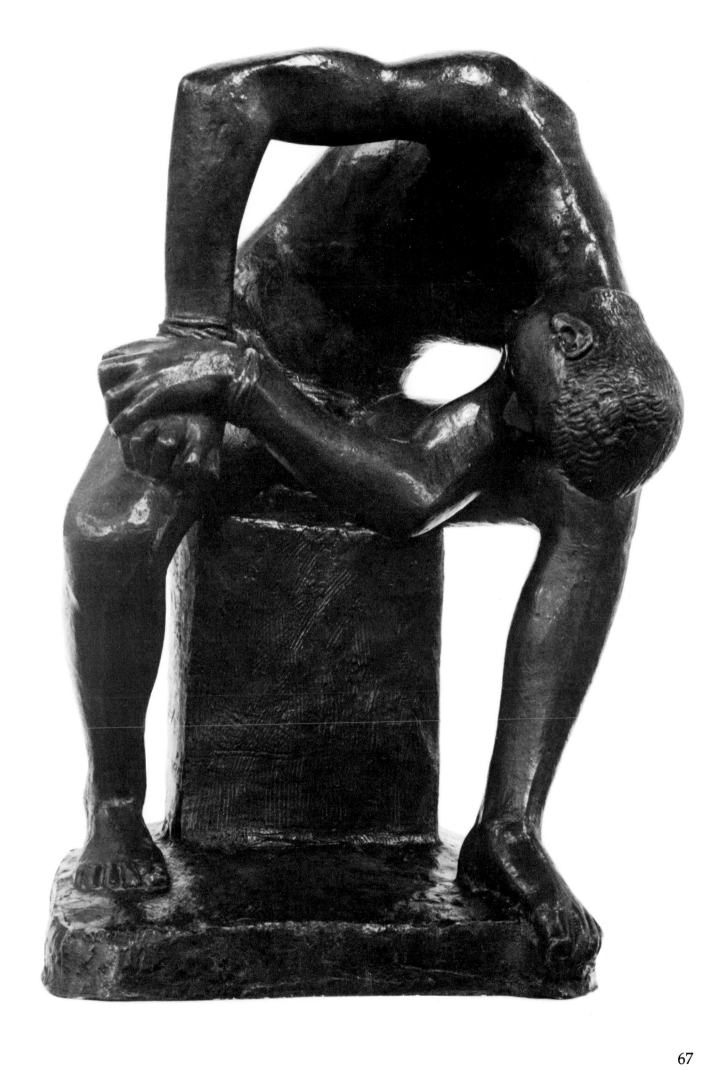

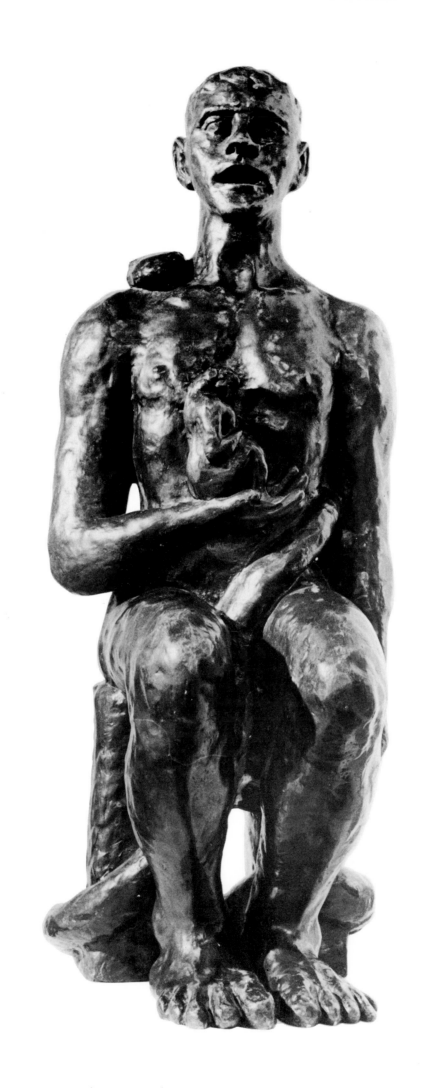

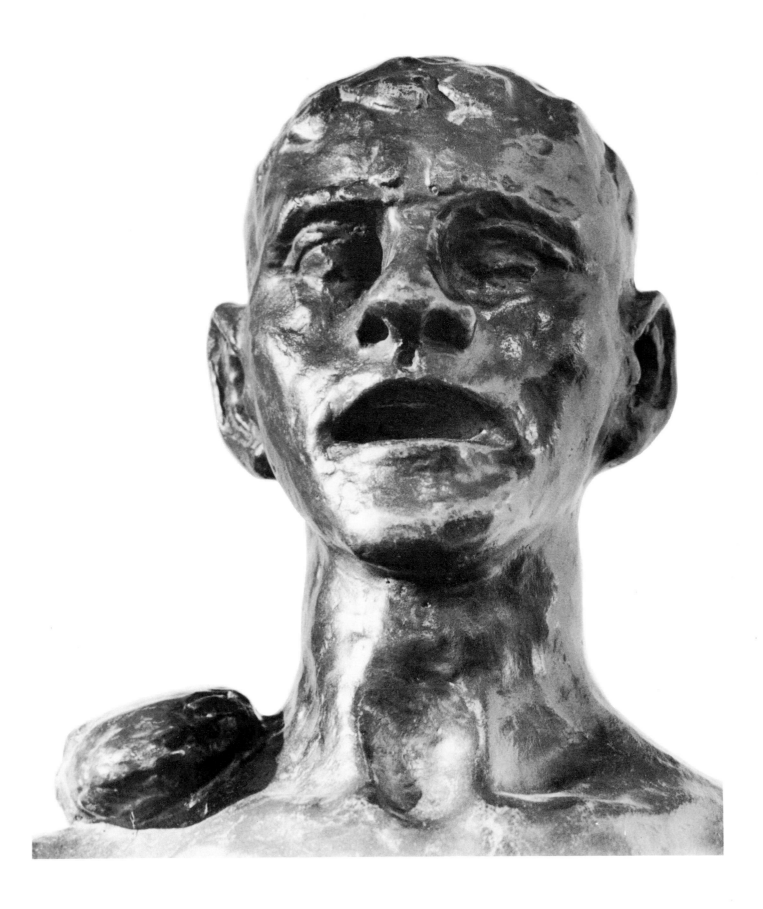

Max Beckmann

(1884–1950) *Adam and Eve*, 1936, bronze, h. 83.3 cm. Gift, Mr. and Mrs. Irving Rabb, 1976.5.
 This unusual interpretation of the Adam and Eve theme, with the small figure of Eve resting in Adam's hand and the serpent encircling Adam, is one of Beckmann's rare sculptures.

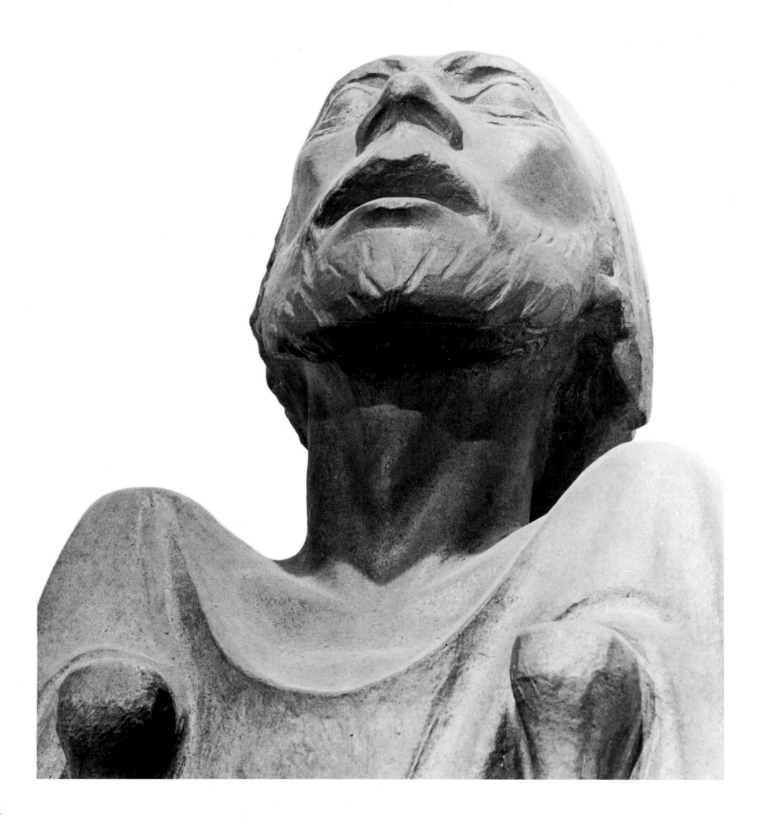

Ernst Barlach

(1870–1938) *Crippled Beggar*, 1930, terracotta, h. 221 cm. Museum purchase, 1931.5.

The *Crippled Beggar* was one of a projected series of sixteen figures entitled *The Community of Saints*, intended for niches in the facade of the Church of Saint Catherine in Lübeck. Barlach completed three figures before National Socialists put an end to the ambitious project. He never saw them installed. After World War II Gerhard Marcks was employed to complete the commission. The figures were finally installed in 1947.

There are two casts of the *Crippled Beggar*: one in the Busch-Reisinger Museum, the other in Lübeck. The beggar's face is raised as his emaciated body rests on crutches, feet barely touching the ground, in an expression of human striving and religious aspiration.

Though Barlach's work was banned by the Nazis as "degenerate" and typical of "the passive Slavic soul," the artist continued to live in Germany until his death in 1938.

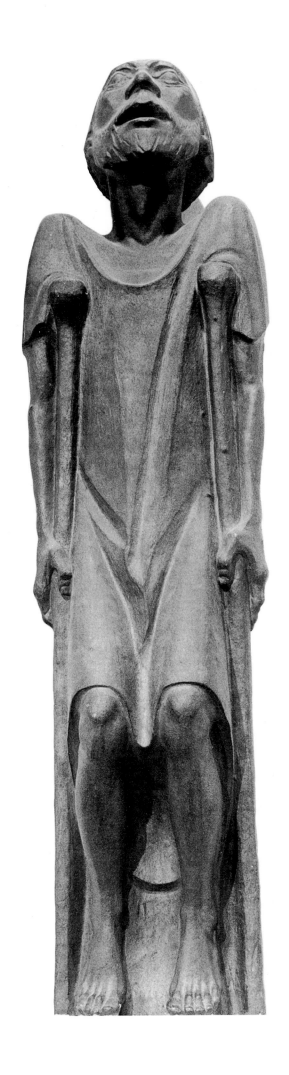

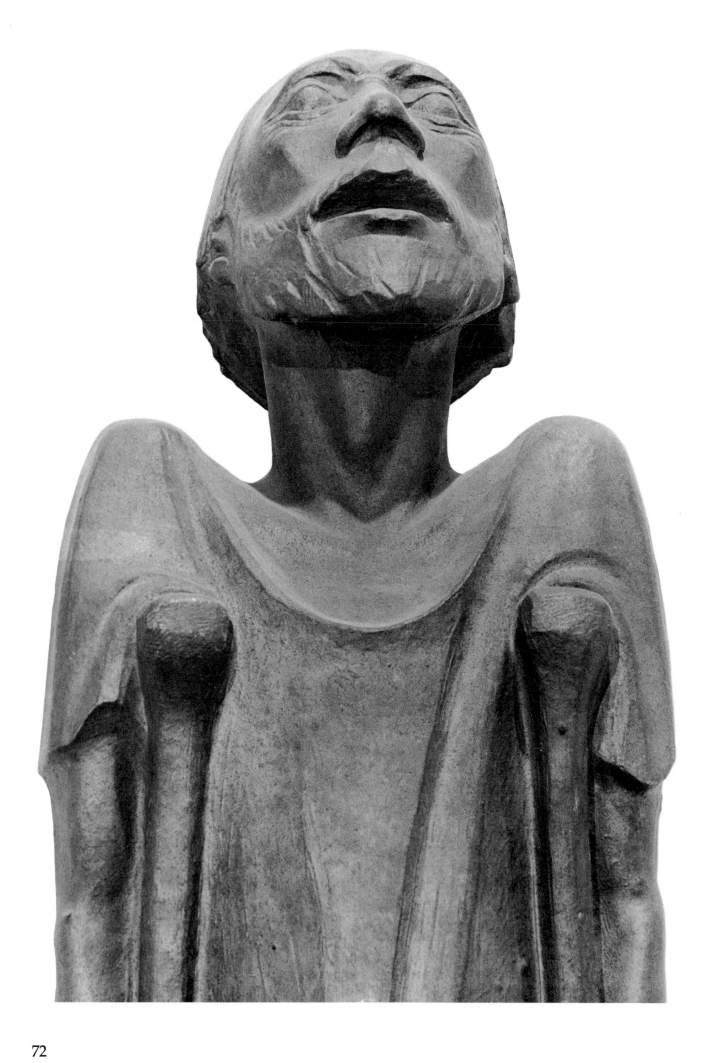

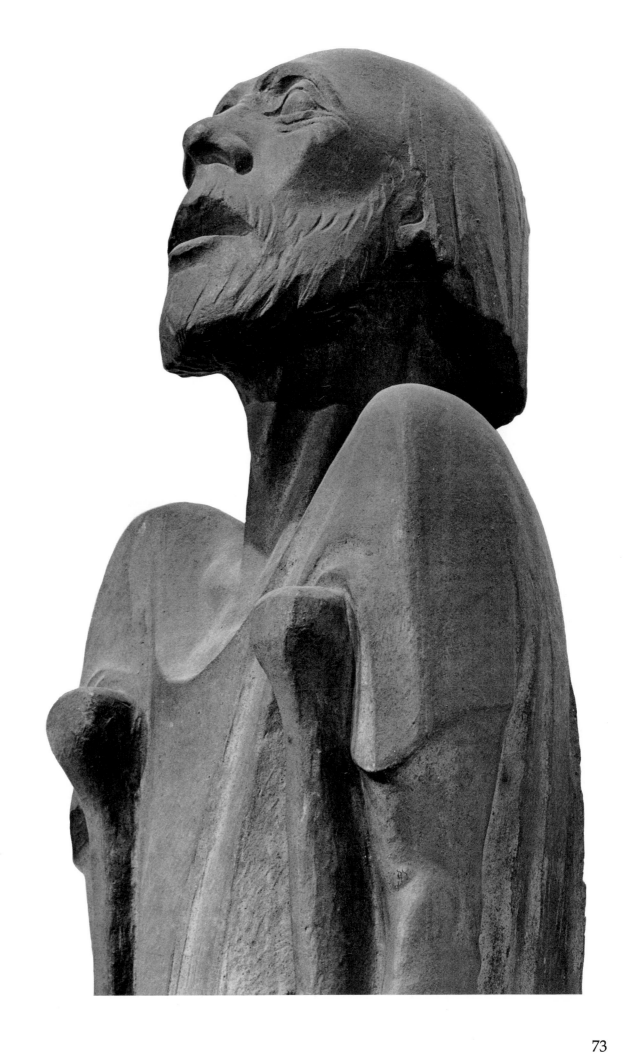

Ernst Barlach

(1870–1938) *Seated Girl,* 1937, amaranth wood, h. 50.2 cm. Gift, Mrs. George P. F. Katz in memory of her husband, 1975.2.

Seated Girl is one of five Barlach sculptures in the Busch-Reisinger Museum, and the only example in wood. It was completed in 1937, the year before the artist's death. This late work is a reprise of a smaller porcelain version, also in the Museum, which the artist executed three decades earlier. In both works one sees his sympathy for the simplicity of peasant life. In 1932 Barlach said, "I desire nothing whatever other than to be an artist pure and simple. It is my belief that that which cannot be expressed in words can, through form, be comprehended in someone else's soul."

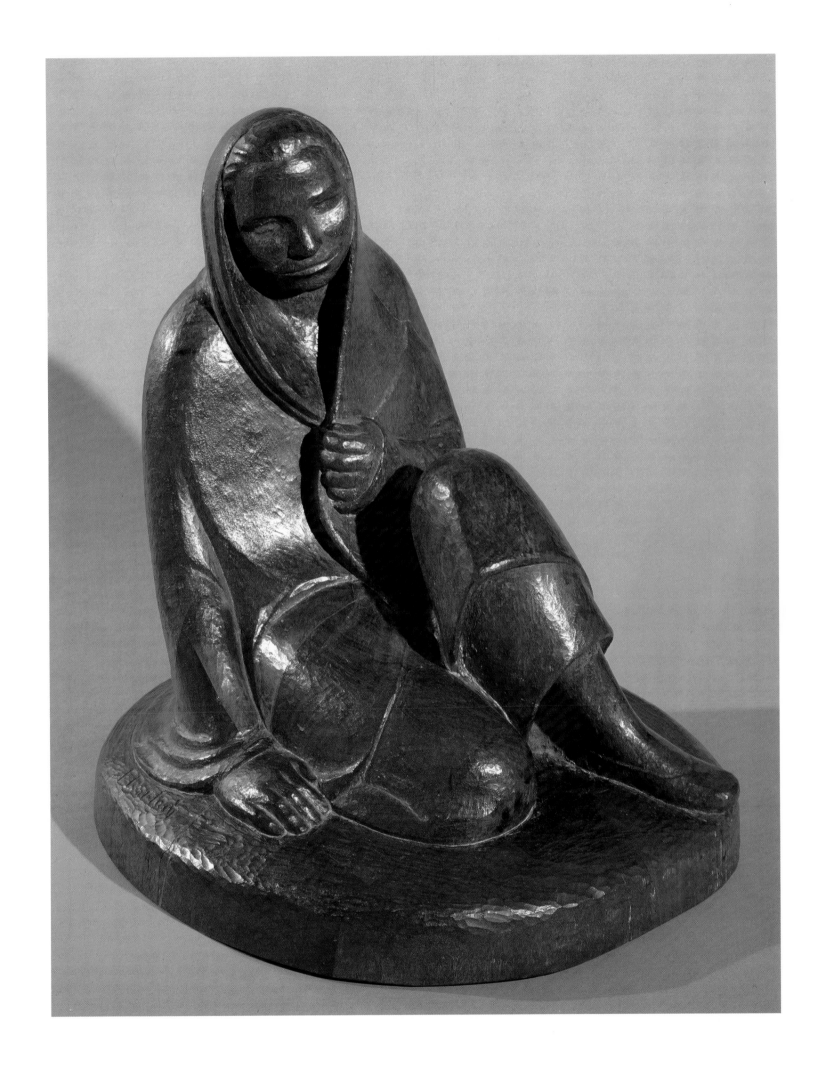

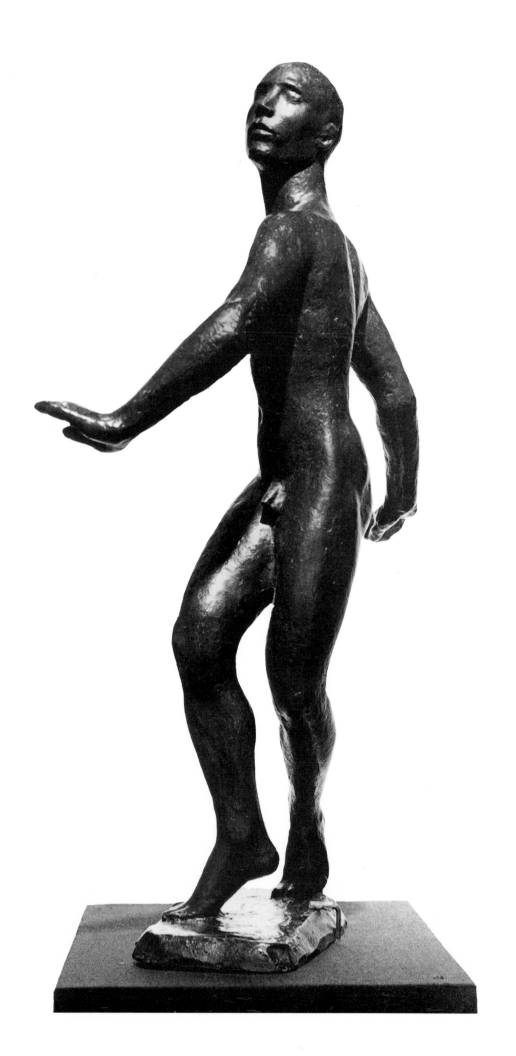

Georg Kolbe

(1877–1947) *The Dancer*, 1914, bronze, h. 63.5 cm.
Anonymous gift in memory of Minnie S.
Kuhn, 1932.64.
 This small bronze, which splendidly
exemplifies Kolbe's interest in the human form
in movement, was inspired by a performance of
the Russian dancer Nijinsky.

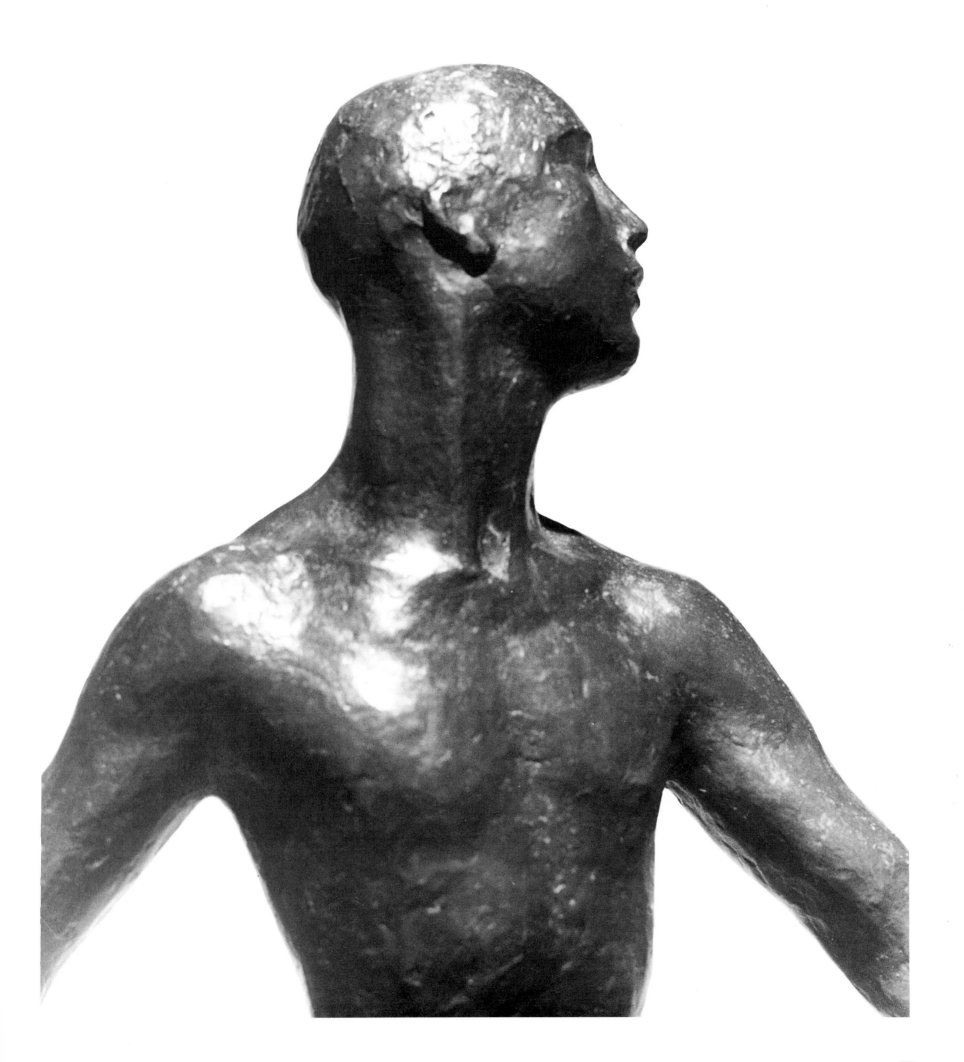

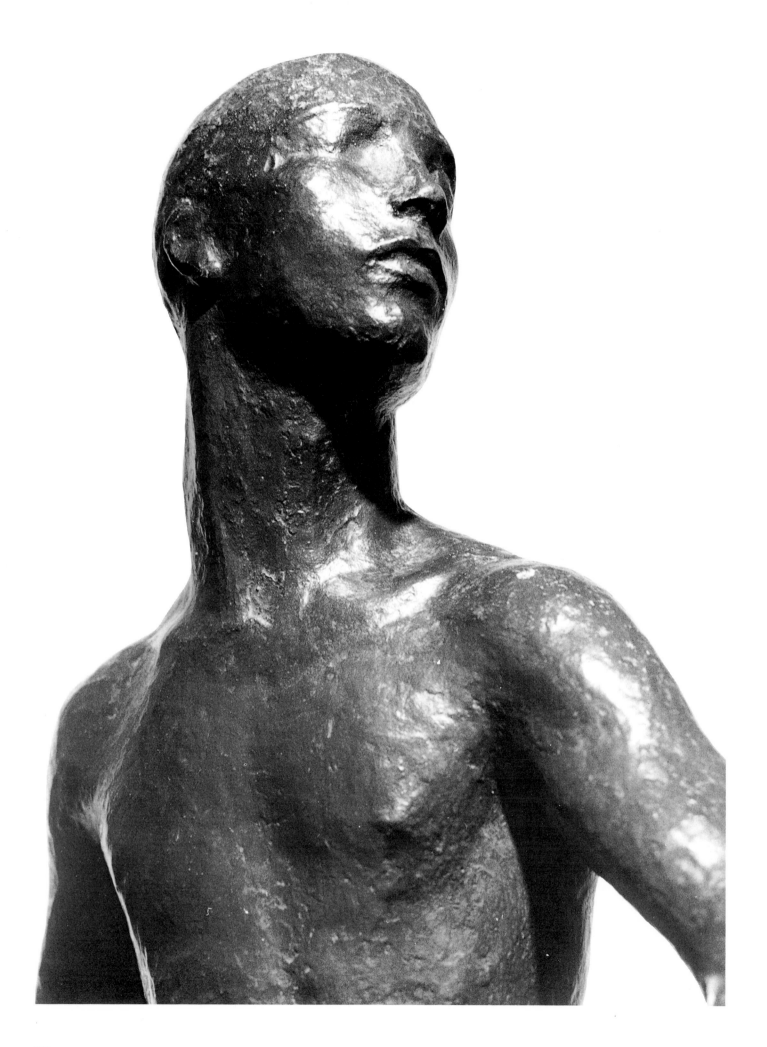

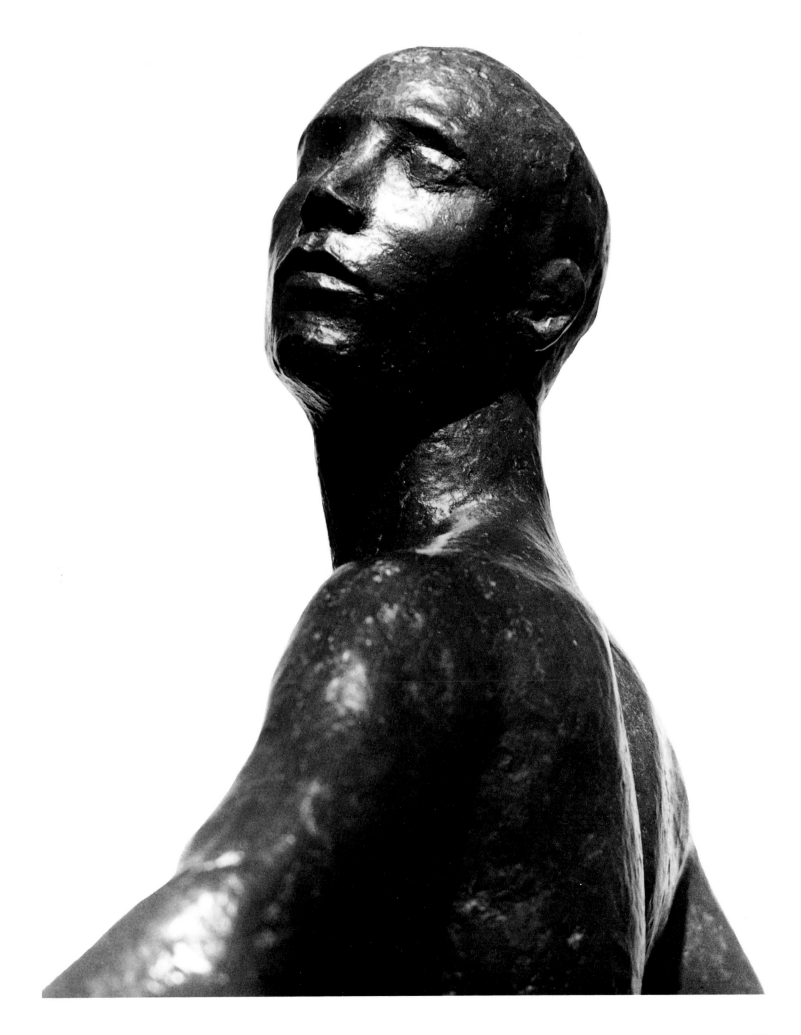

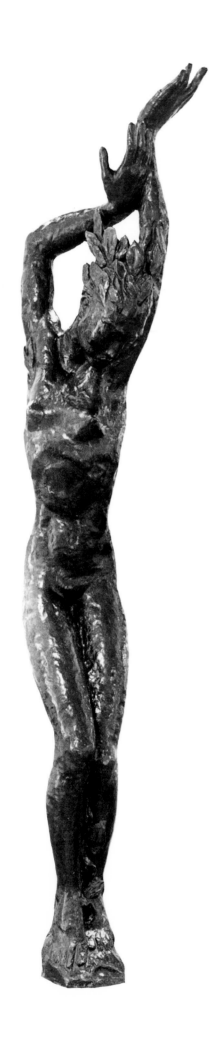

Renée Sintenis

(1888–1965) *Daphne,* 1917, bronze, h. 144.8 cm. Gift, Mrs. Charles L. Kuhn, 1959.49.
 The young nymph is depicted at the moment she is being transformed into a laurel tree. This version of *Daphne,* which captures the lithe grace of a girl just reaching maturity, was commissioned in 1930 for the garden of the museum in Lübeck. The Busch-Reisinger collection also has a smaller version of *Daphne.*

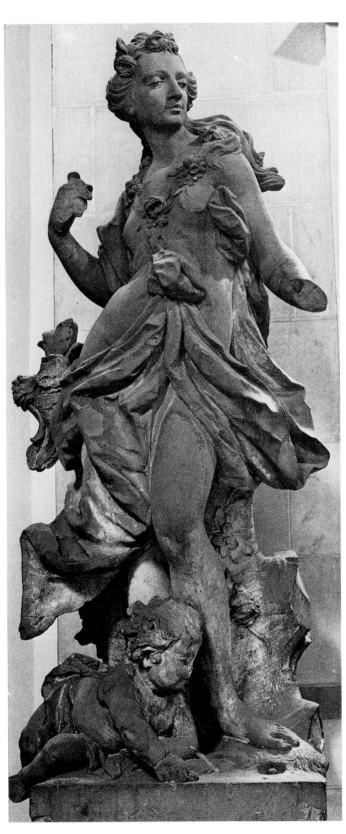

Attributed to **Johann Joachim Günther**

(1717–1789) *Spring* from *The Four Seasons,* c. 1760–65, sandstone, h. 236 cm. Purchase, Alpheus Hyatt Fund, Fogg Museum 1952.11a.

 The Four Seasons are outstanding examples of monumental German baroque sculpture. Pieces of this importance are seldom seen outside Germany. The group was part of the garden decoration of the Palace of Bruchsal in Baden. The gardens included two other series of sculptures, *Four Halberdiers* and *Four Elements*; all twelve originated in the workshop of Johann Joachim Günther.

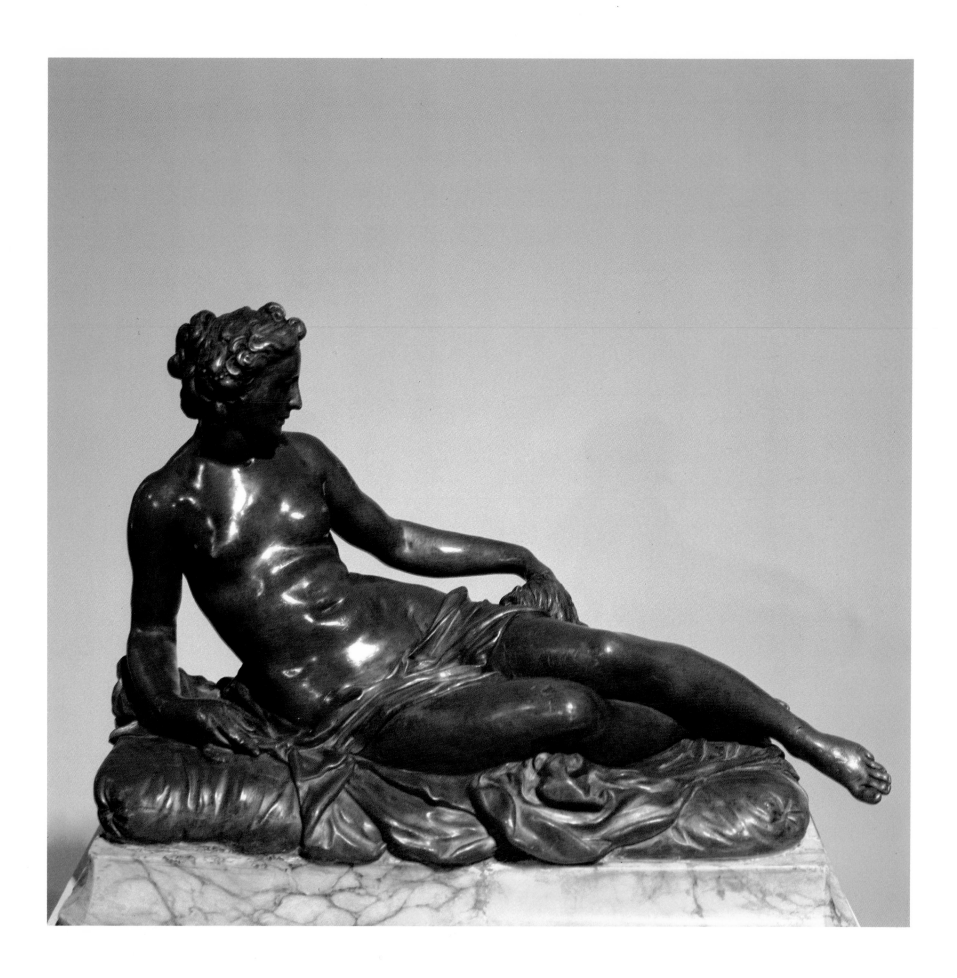

Georg Raphael Donner

(1693–1741) *Reclining Nymph,* c. 1739, lead statuette on marble base, h. 25.4 cm. Purchase, Museum Association Fund, 1964.7.

The *Reclining Nymph* is related to Donner's most famous work, the fountain for the Neuer Markt in Vienna. The fountain's two female figures, personifying the rivers March and Ybbs, are strikingly similar to the Busch-Reisinger statue. This well-preserved cabinet piece, made of lead, is a precious example of Donner's masterful modeling and languid elegance. Another cast of the *Reclining Nymph* is in the Baroque Museum of Vienna.

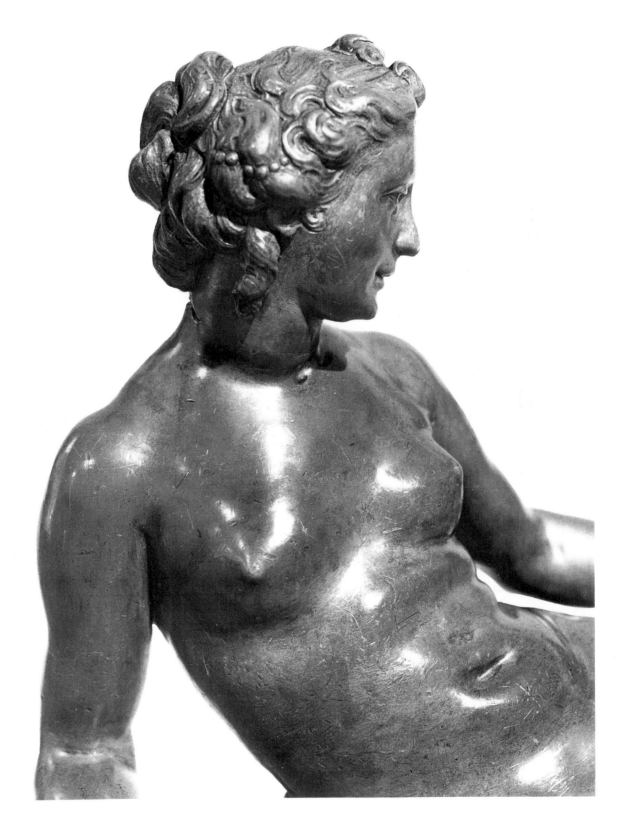

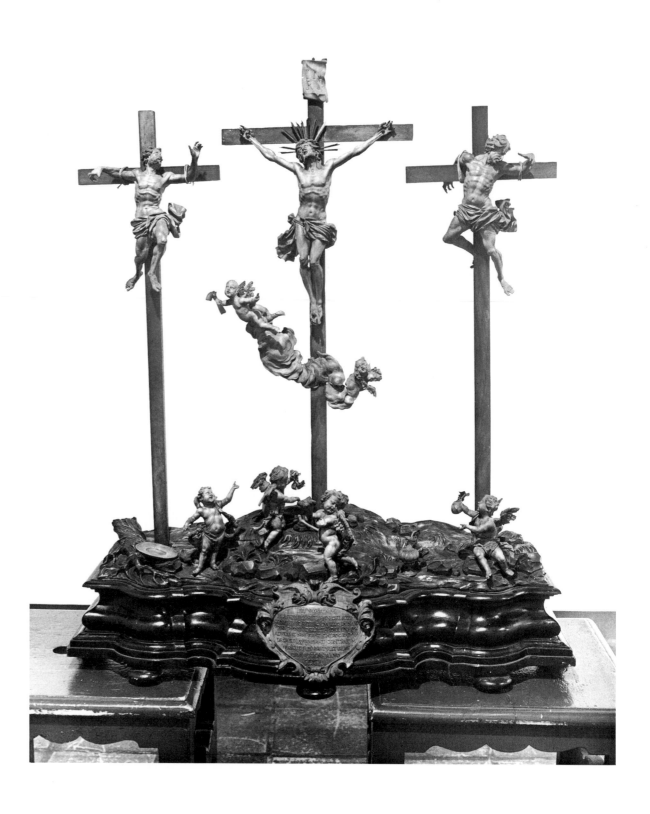

Upper Austrian School

Crucifixion, c. 1700–25, pearwood (?), h. 84 cm. Gift, W. B. Osgood Field, Fogg Museum, transferred to Busch-Reisinger Museum, 1965.2.

The sculptor of this *Crucifixion* signed his initials *I.W.* on the work. Although the ornament on the base, the drapery of the three figures on the crosses, the tiny angels, and the multiplicity of detail indicate that the work dates from the first decades of the eighteenth century, the influence of Georg Petel's art of a full century earlier is strongly marked. The detailed treatment of the anatomy, the complex handling of the folds of the loincloth, and the type of angels with their small wings find parallels in the work associated with the Schwanthaler family at Ried in Upper Austria. The *Crucifixion* was probably intended for the altar of a small chapel.

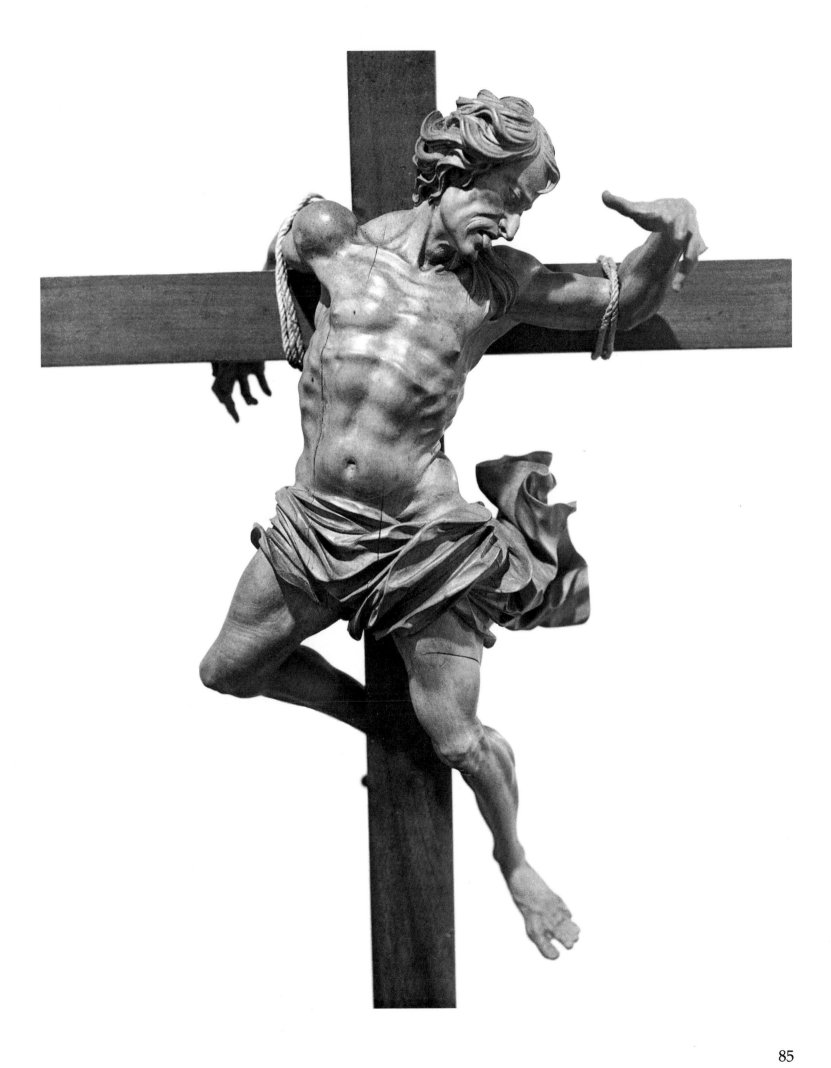

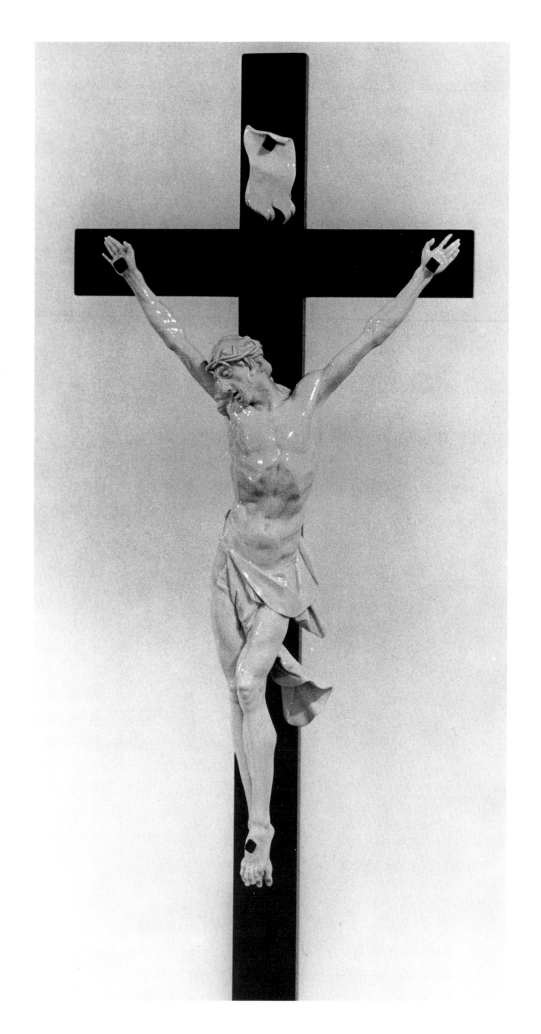

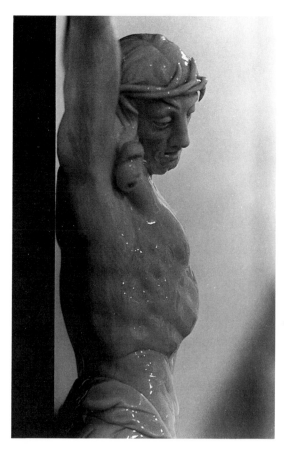

Franz Anton Bustelli

(1723–1763) *Crucifix,* Nymphenburg porcelain, h. 35.5 cm. Long-term loan, William A. Coolidge.

 Bustelli, master modeler at the Nymphenburg porcelain works, is best known for his decorative harlequin and arcadian figures. This crucifix is a moving example of one of his rare religious pieces.

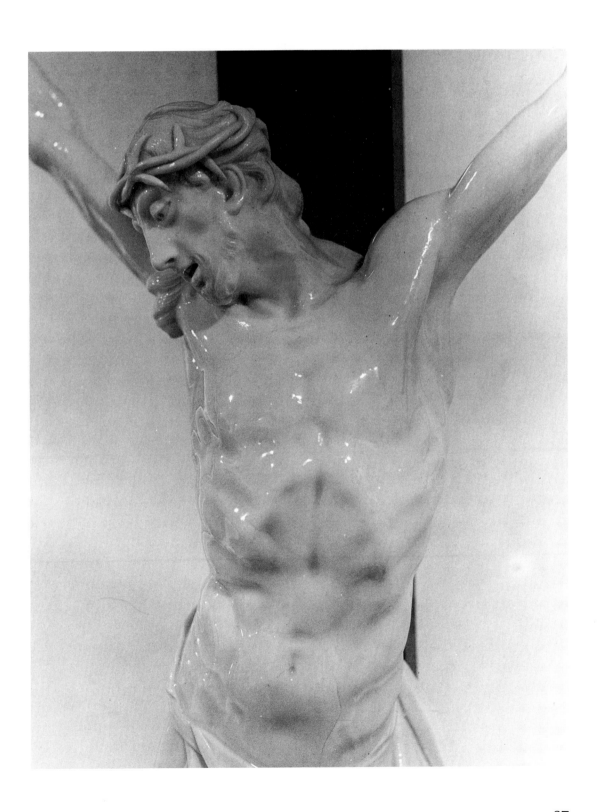

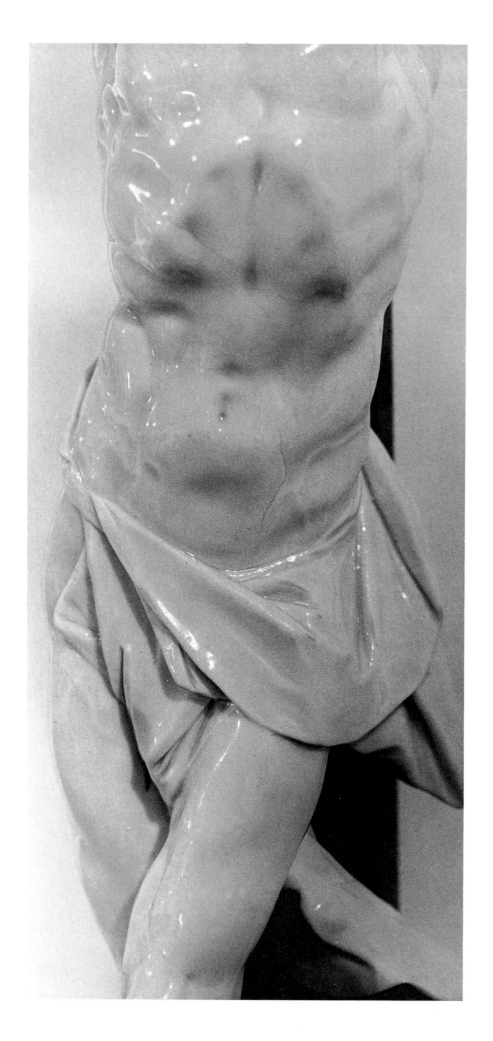

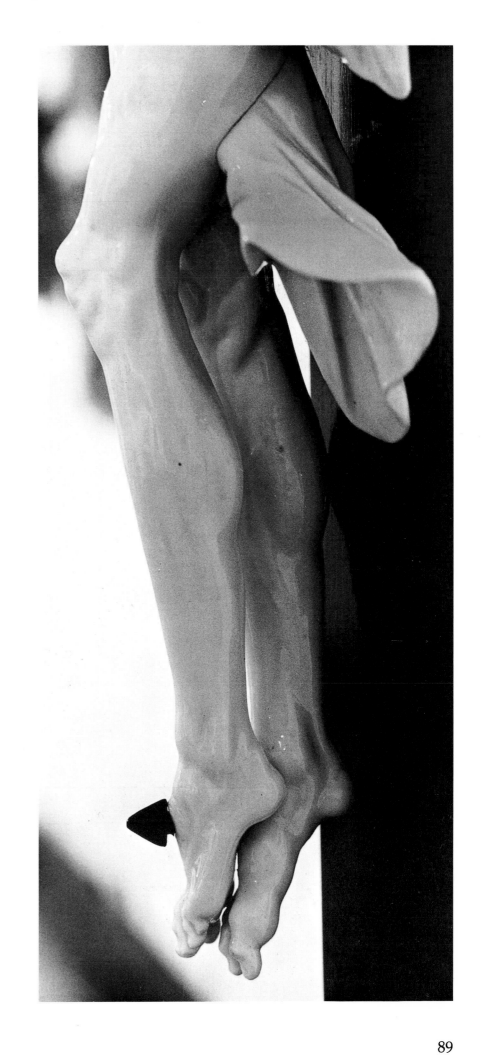

Austrian School

Saint Augustine, c. 1725–50, polychromed lindenwood, h. 229 cm. Purchase, Museum Association Fund, 1959.126.

This is a pendant to Saint Ambrose, which is also in the Busch-Reisinger collection. The pair probably flanked the central section of an altarpiece, the most frequent position for bishop saints on southern German and Austrian retables during the seventeenth and eighteenth centuries.

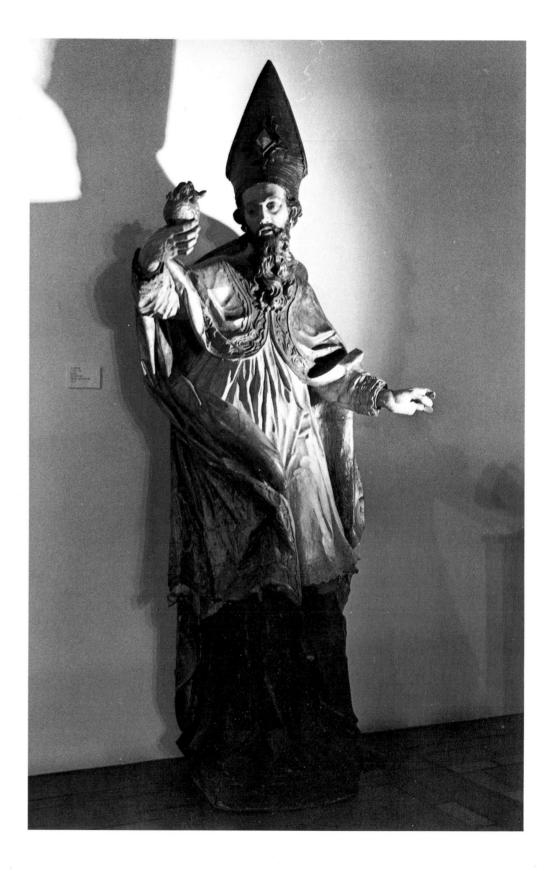

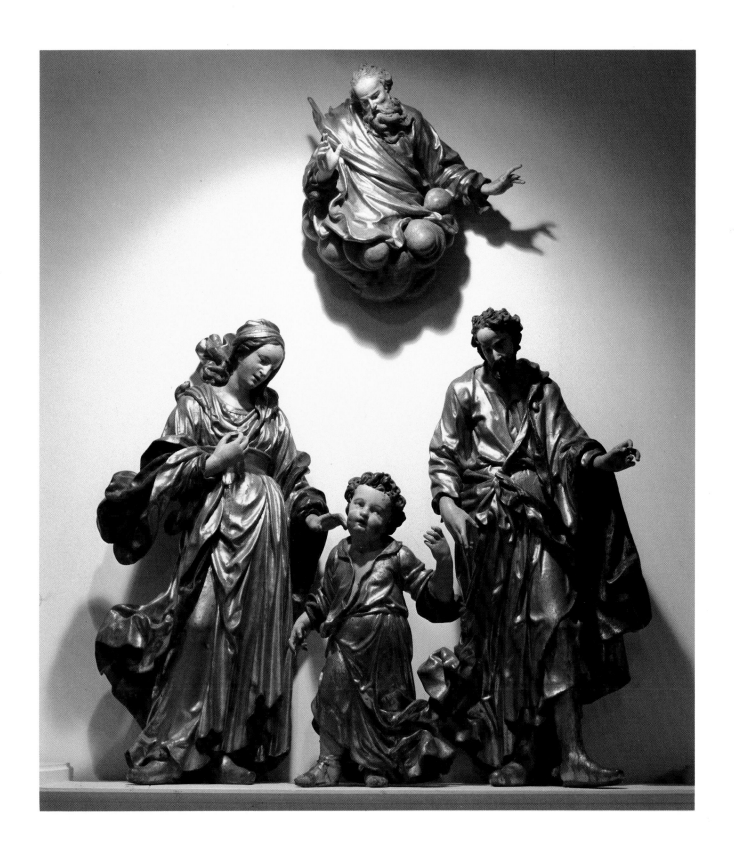

Meinrad Guggenbichler

Return of the Holy Family from Egypt, c. 1690, polychromed lindenwood, h. of Madonna 77 cm., Saint Joseph 76 cm., the Christ Child 49 cm., God the Father 44.5 cm. Purchase, Museum Association Fund, 1956.275.

The altar that these figures originally embellished was probably of the early baroque type in which the central scene was flanked by pairs of spiral columns. Meinrad Guggenbichler was one of the most successful sculptors of his generation in the Salzburg area.

South German School

Angel, c. 1600–1620, polychromed lindenwood, h. 114 cm. Purchase, Museum Association Fund, 1964.34.

 The figure is probably an angel, in spite of the absence of wings. Similar wingless angels occur in Bavarian baroque sculpture around this time. The many common features of the Busch-Reisinger angel and the work of Munich-Weilheim artists, such as Krumper and Degler, support an attribution to that area of southern Germany and a date between 1600 and 1620.

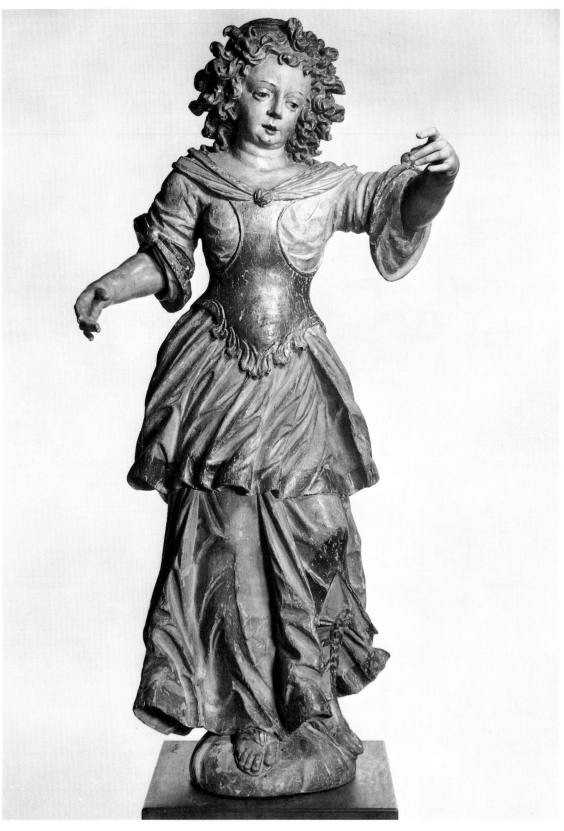

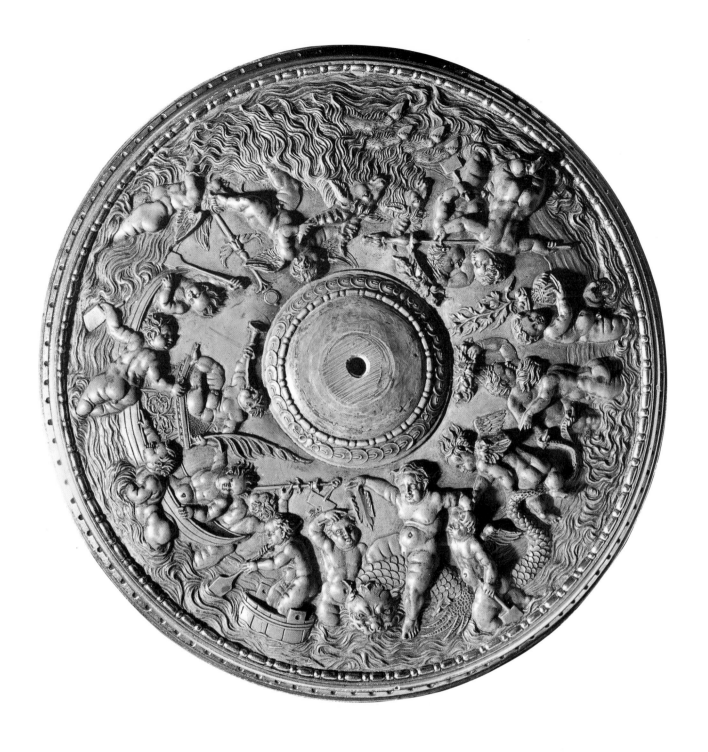

Peter Flötner

(1485–1546, German School) *Triumph of a Sea-Goddess,* c. 1530, steatite, diam. 17.5 cm.
Purchase, Museum Association Fund, 1951.213.

 This steatite relief, datable to the 1530s, was designed as a model for Nuremberg
goldsmiths and was most likely intended as the base for an elaborate goblet or pitcher. A
preparatory drawing for it is at the Herzog Anton Ulrich Museum in Braunschweig and a
bronze cast based upon it is at the Musée des Arts Décoratifs, Paris. The subject of the relief
is the triumph of a sea-goddess or nymph, a popular classical theme. However, unlike most
ancient and Renaissance artists, Flötner made children, not adults, the protagonists of his
relief. The finely preserved carving is particularly precious because Flötner's most
important sculptural undertakings, the Fugger Burial Chapel of Augsburg and the
Hirschvogel House in Nuremberg, were destroyed in World War II. Only a handful of other
carvings exist.

Franconian School

Education of the Virgin, c. 1510–1520, polychromed lindenwood, h. 84 cm. Gift, Mrs. Felix M. Warburg in memory of her husband, 1941.35.

Saint Anne instructing the Virgin is a rare iconographic theme until the late Middle Ages, although it is related to the *Anna Selbdritt,* which stems from the thirteenth-century cult of Saint Anne. The dating of this group is fairly certain. The drapery, deeply undercut but in general suggesting the disposition of the bodies beneath it, is characteristic of the early years of the sixteenth century. Most of the polychromy has disappeared, and there remains only enough to recall the original colors.

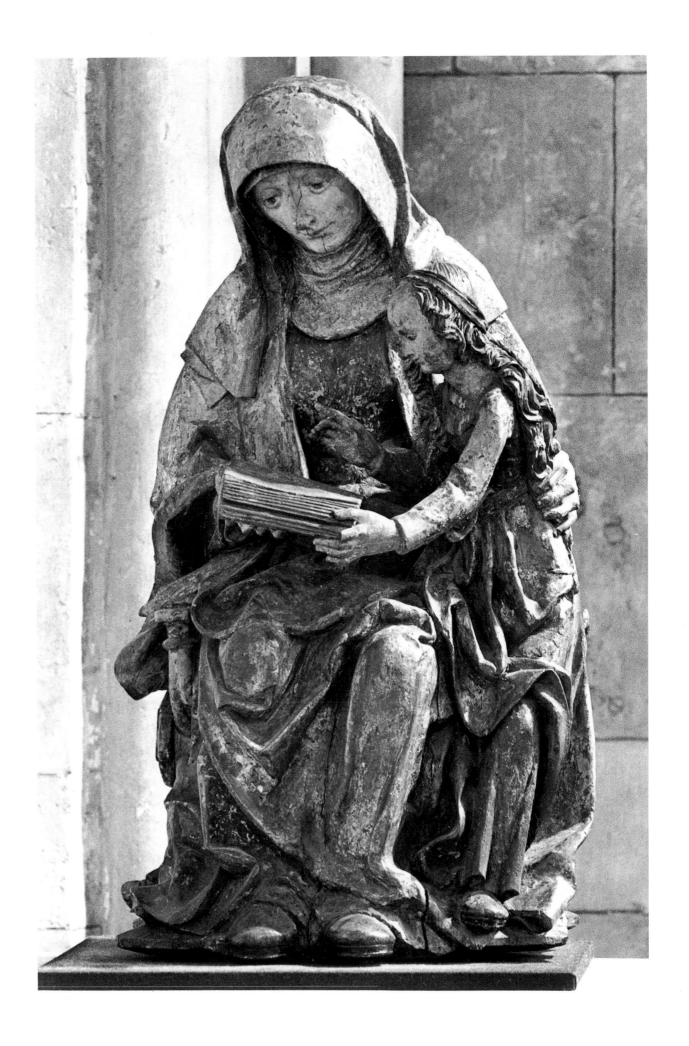

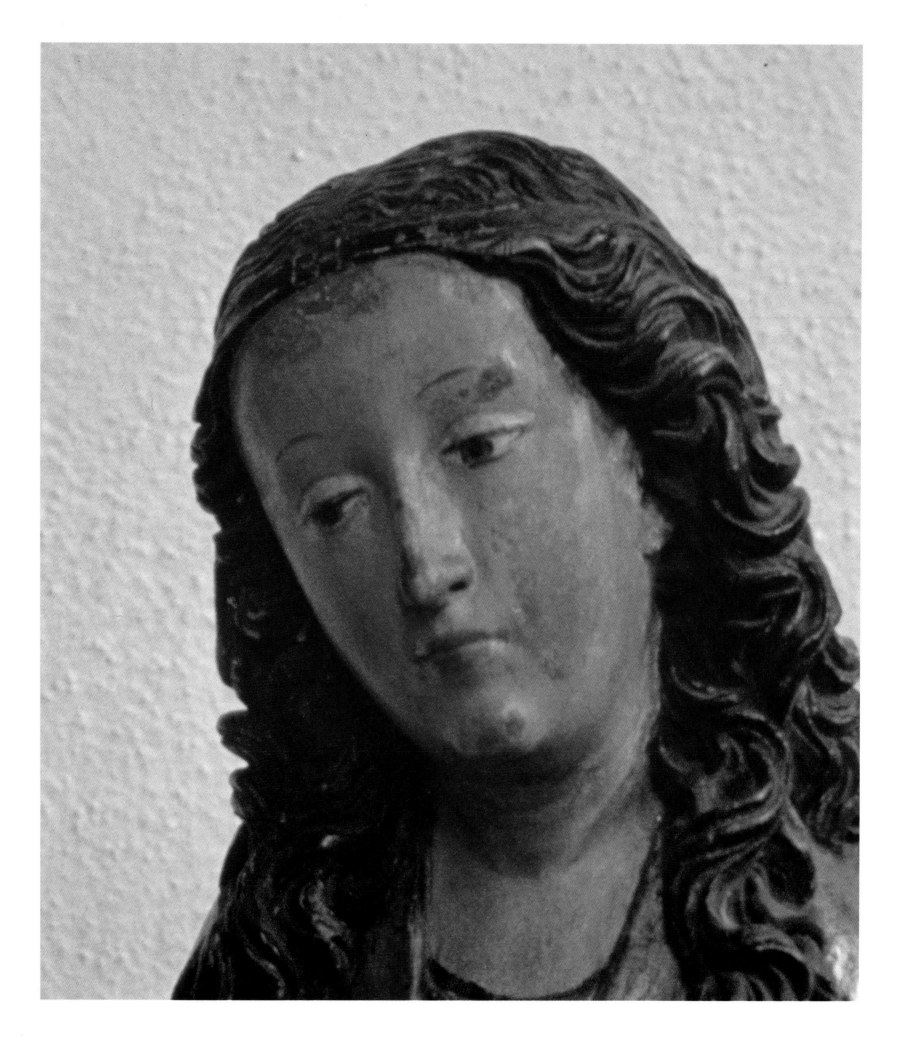

Upper Rhenish School

Nativity, c. 1500, polychromed lindenwood, h. 72 cm. Purchase, anonymous funds, 1963.1.

 The work is said to have once been in the village of Tettnang near the shore of Lake Constance, and an old photograph reveals that Saint Joseph was placed behind the Virgin. The relatively high relief suggests that the group formed the central section of an altarpiece. It is related stylistically to several works of sculpture from the Upper Rhenish and Constance regions and to a number of carvings by Hans Olmütz. The calm majesty of the Madonna contrasts with the glittering restlessness of the deeply undercut drapery which forms alternating areas of light and shade.

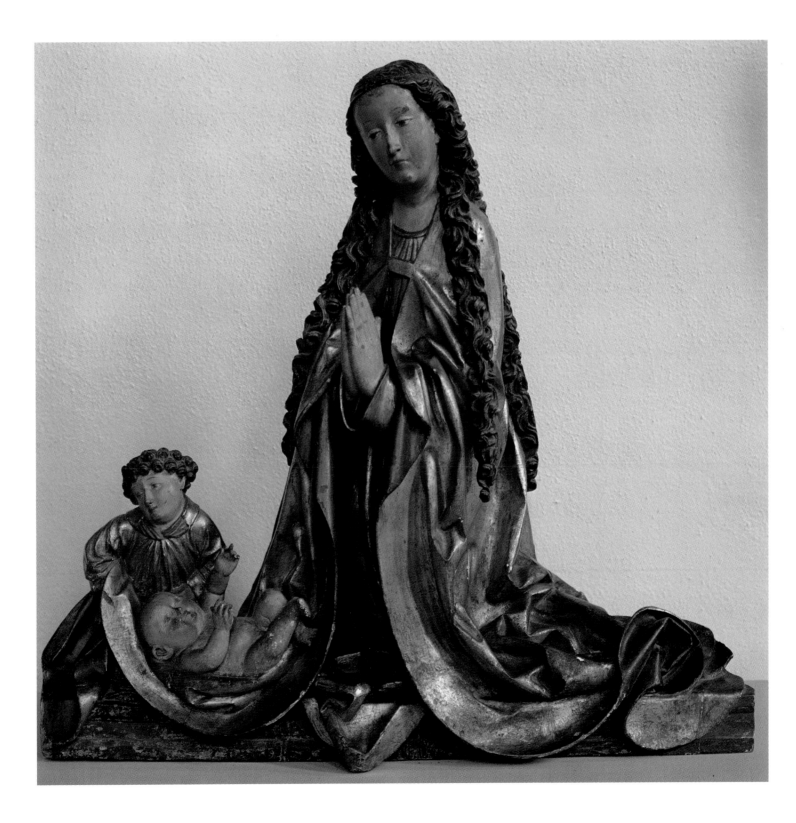

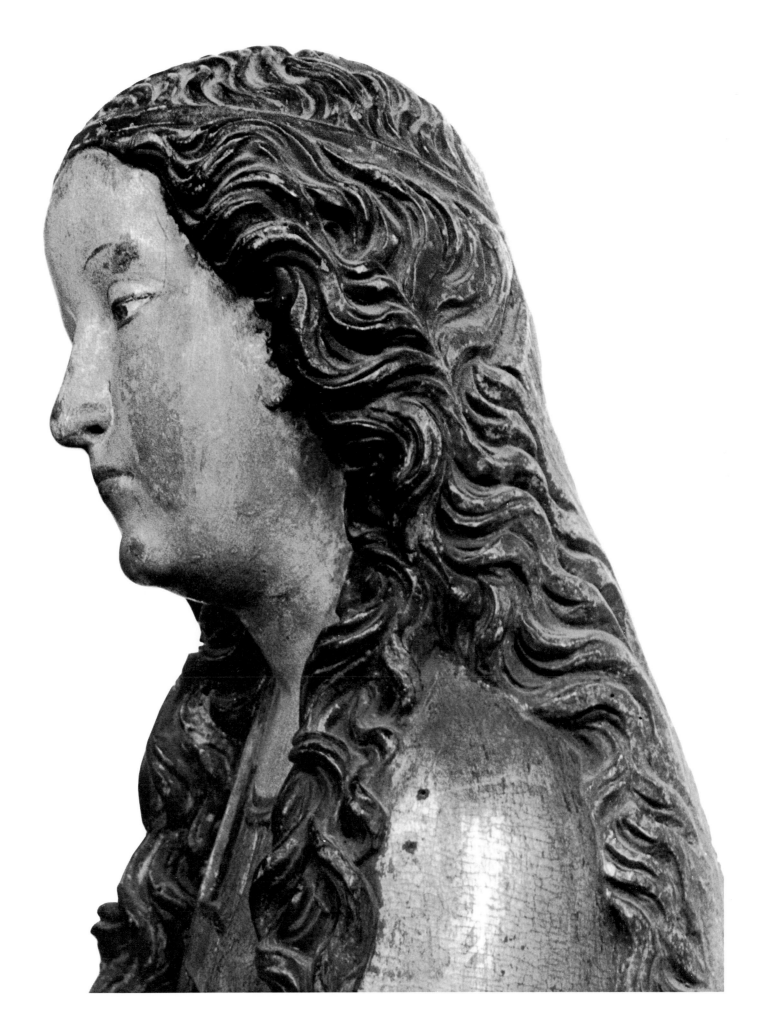

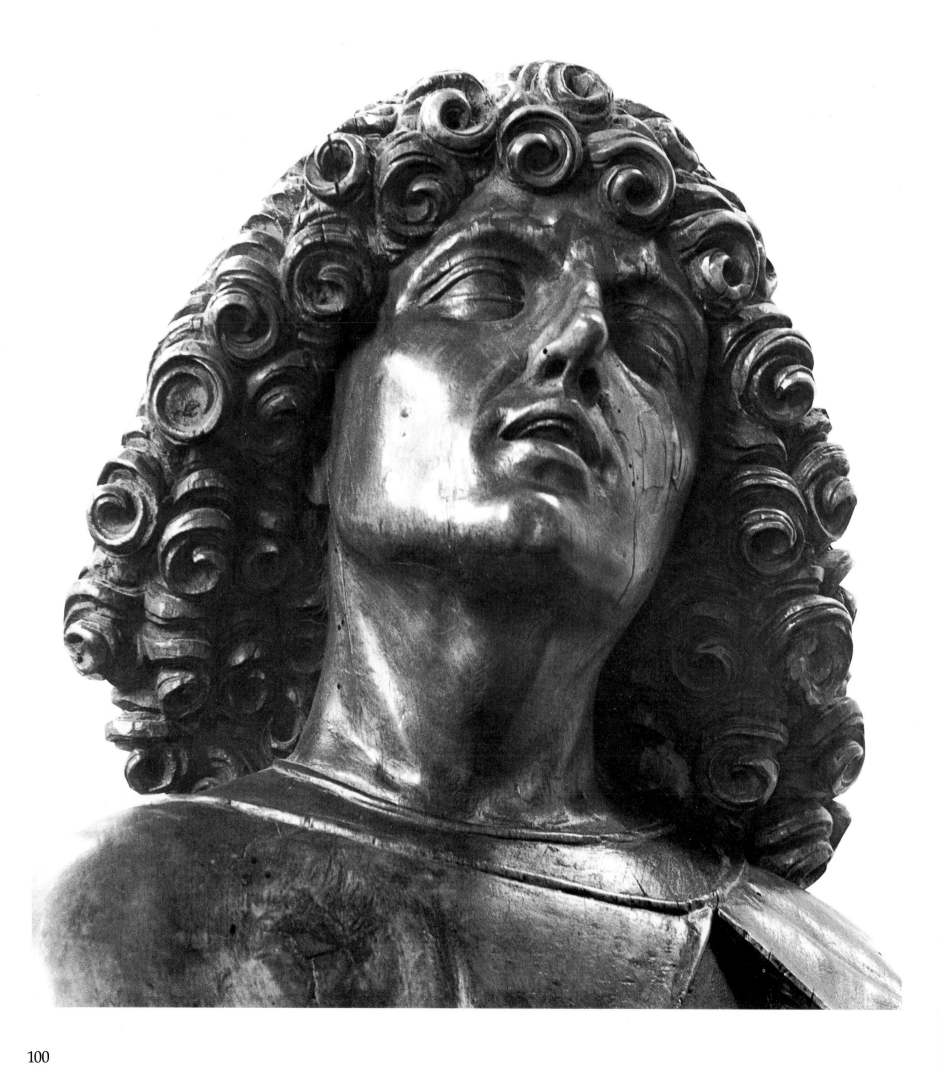

Lower Swabian School

Saint John the Evangelist, c. 1490–1500, polychromed lindenwood, h. 126.5 cm. Gift, Mrs. Solomon R. Guggenheim, 1964.5.

This sculpture was probably once part of a Crucifixion scene. Saint John stands on a base carved to simulate rocky ground. The figure has a strong emotional impact with its vertical folds and strong emphasis on ringlets of hair. It was once polychromed, for traces of the chalk ground are visible in the deepest recesses of the drapery.

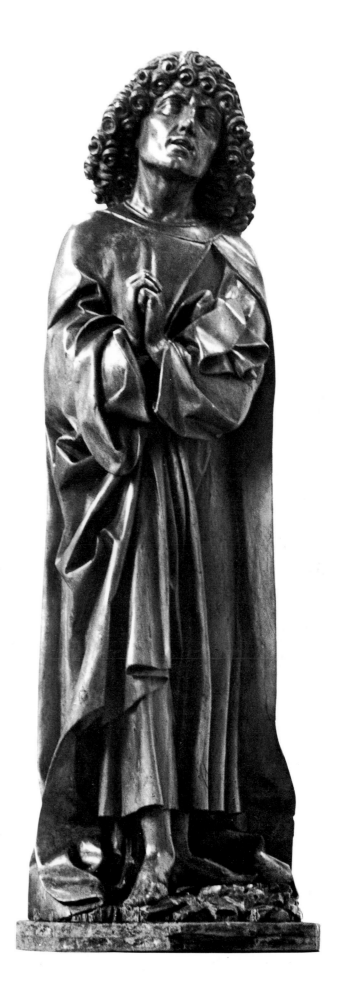

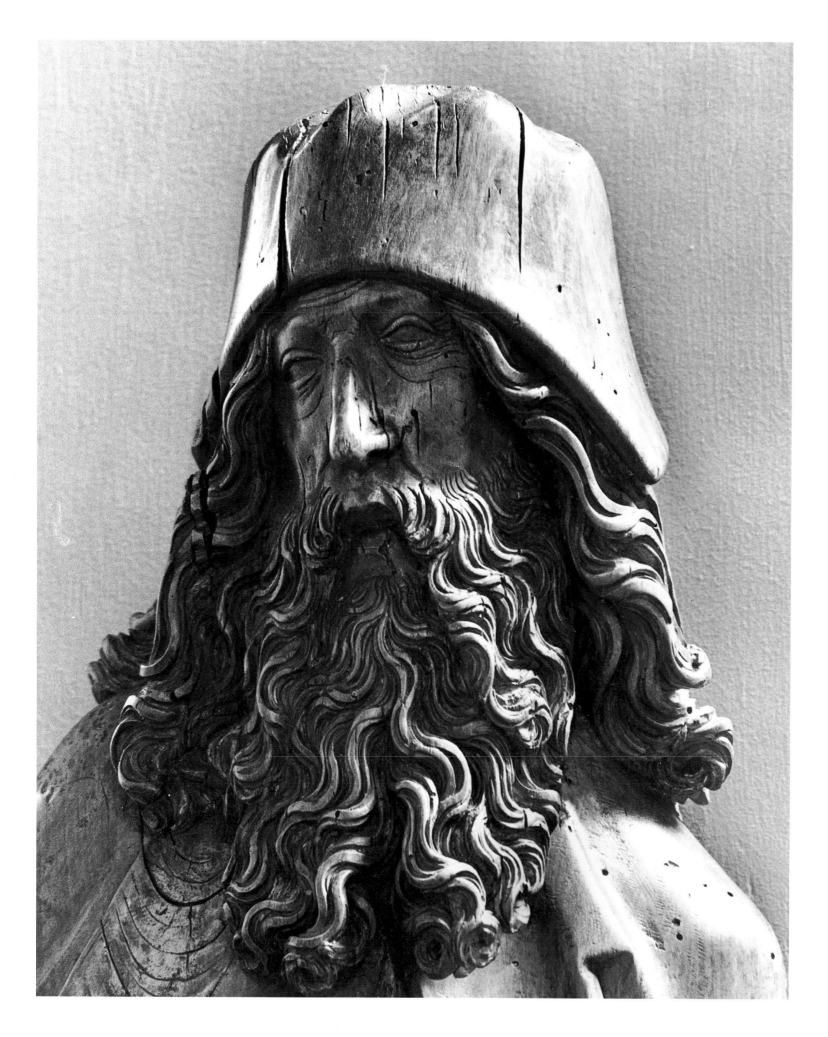

Tilman Riemenschneider

(c. 1450–1531, German School) *Saint Anthony Abbot,* c. 1510, lindenwood, h. 117.5 cm. Purchase, anonymous and special gifts from the friends of Charles L. Kuhn, 1969.214.

Riemenschneider is the most famous German sculptor of the sixteenth century. His *oeuvre* is vast, and he employed a large number of assistants in his Würzburg workshop. *Saint Anthony* was probably partially done by his helpers, but the concentrated expressiveness and fine carving of the head show the hand of the master.

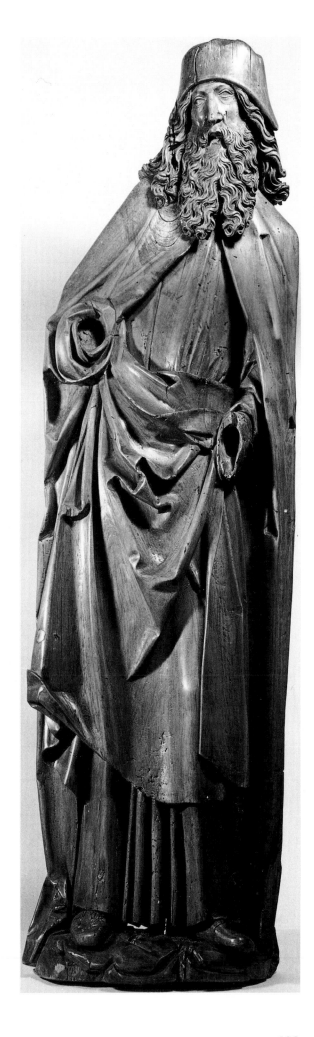

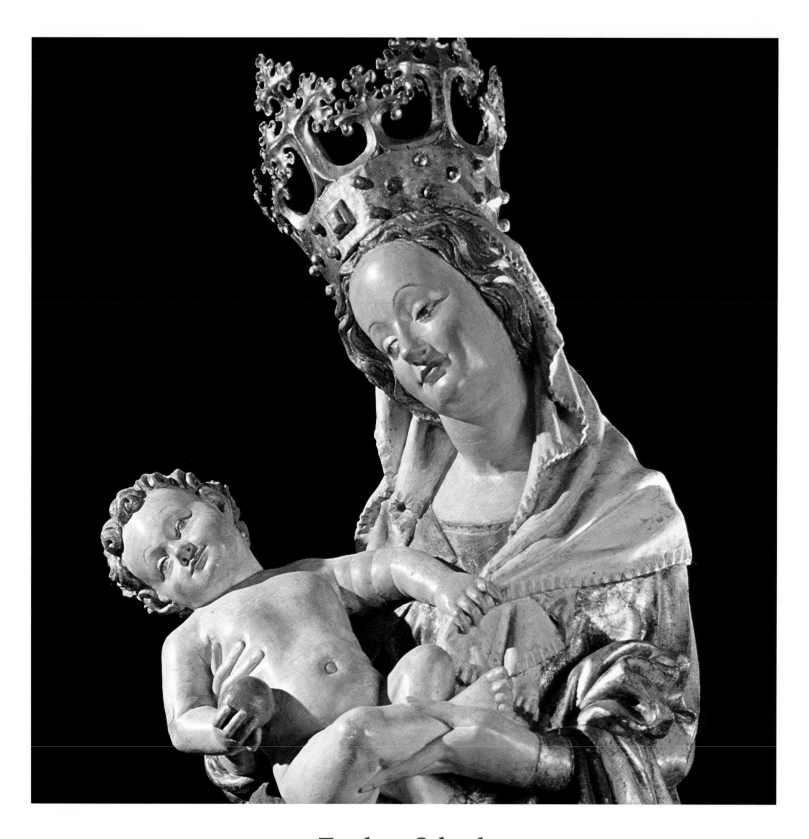

Tyrolean School

Madonna and Child, c. 1430, polychromed wood, h. 155 cm. Museum purchase, anonymous funds, 1963.2.

This sculpture, in an almost perfect state of preservation, is an outstanding example of a type of devotional image known as the *Schöne Madonna* (Beautiful Madonna), popular in central Europe during the late fourteenth and early fifteenth centuries. The Madonna is depicted as the virgin in the Book of Revelations, "a woman clothed in the sun (gold) and the moon under her feet, and on her head a crown." The base of the sculpture contains a reliquary.

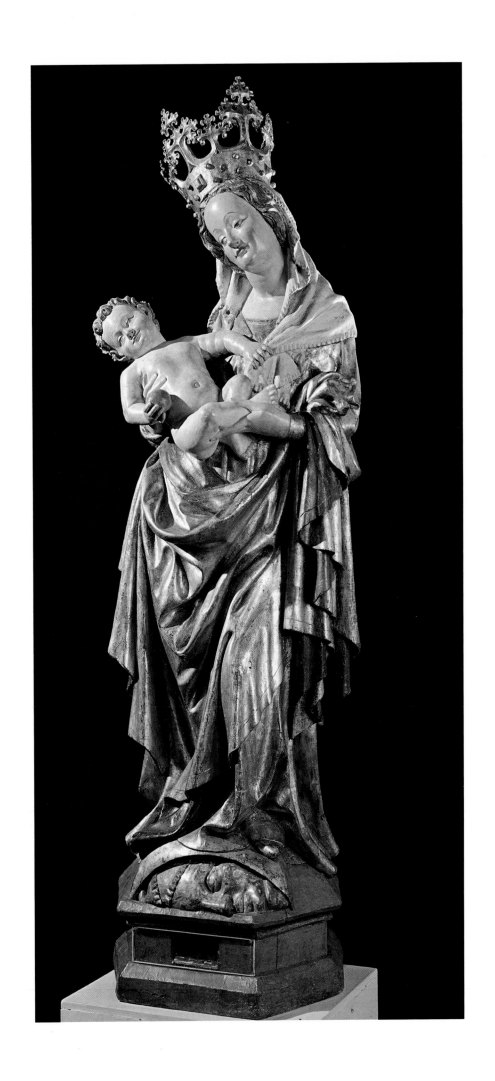

Austrian School

Pietà, c. 1420, polychromed poplar wood, h. 92 cm. Purchase, in memory of Eda K. Loeb, 1959.95.

The Busch-Reisinger *Vesperbild* is a characteristic example of the "soft style" of the early fifteenth century. The slender proportions of the Madonna and her spiritual expression find their closest parallel in the work of the Master of Grosslobming and his circle.

The stiff, angular body of Christ and the restrained expression of grief of the Madonna—clad in voluminous drapery—make this an especially moving devotional image. Such images were designed for private worship and are completely divorced from ecclesiastical architecture. The original polychromy has disappeared except for a few traces.

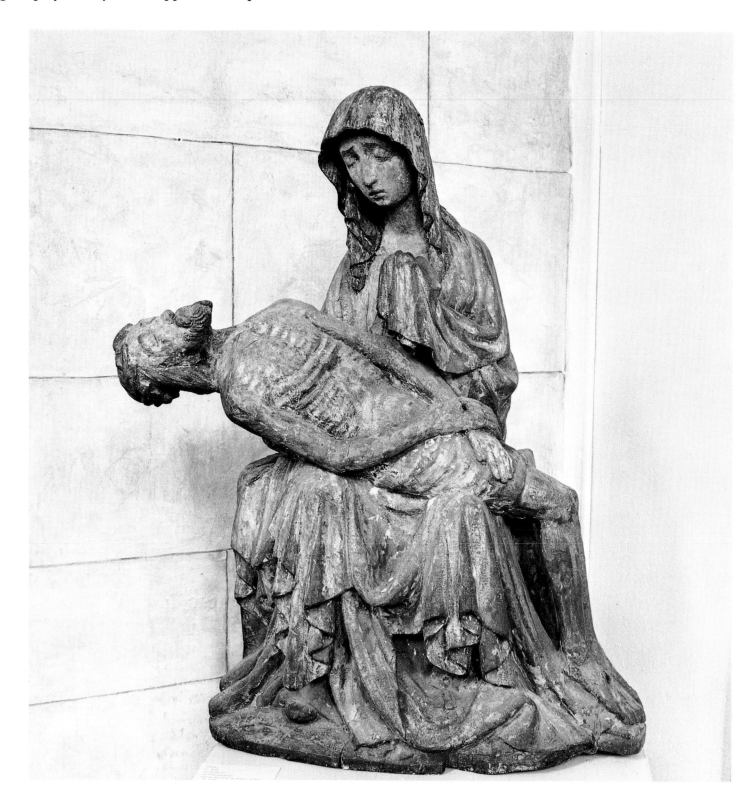

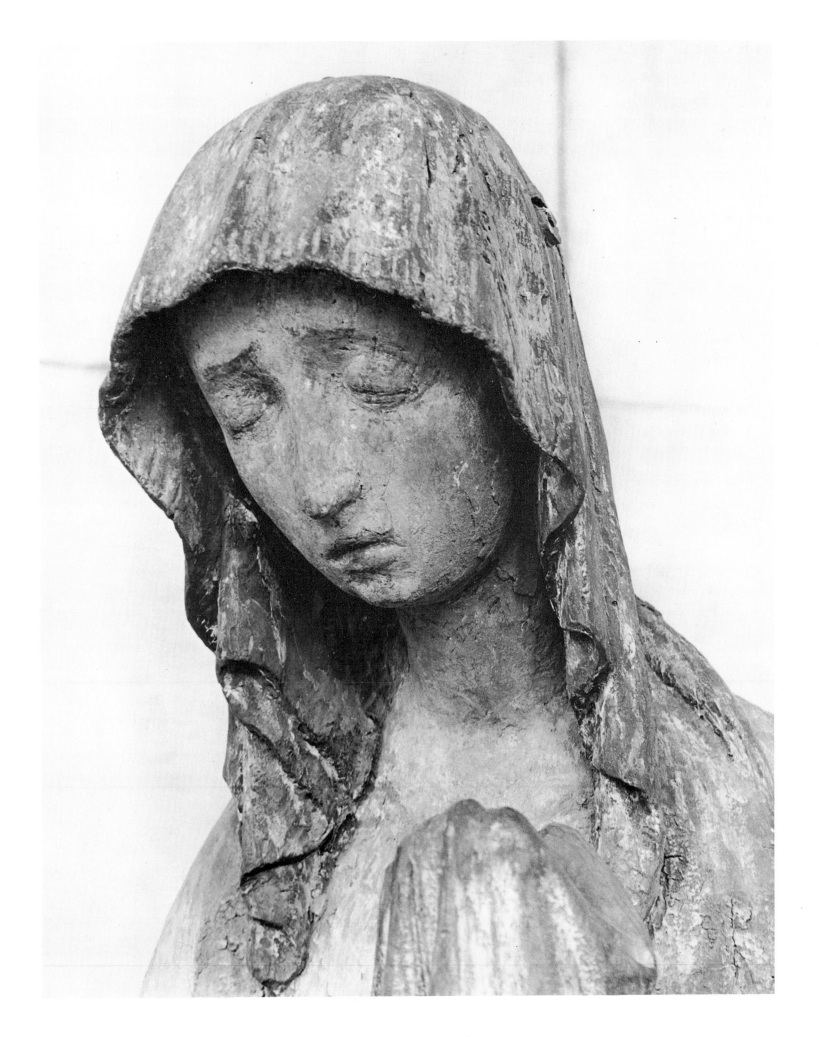

GRAPHIC ARTS

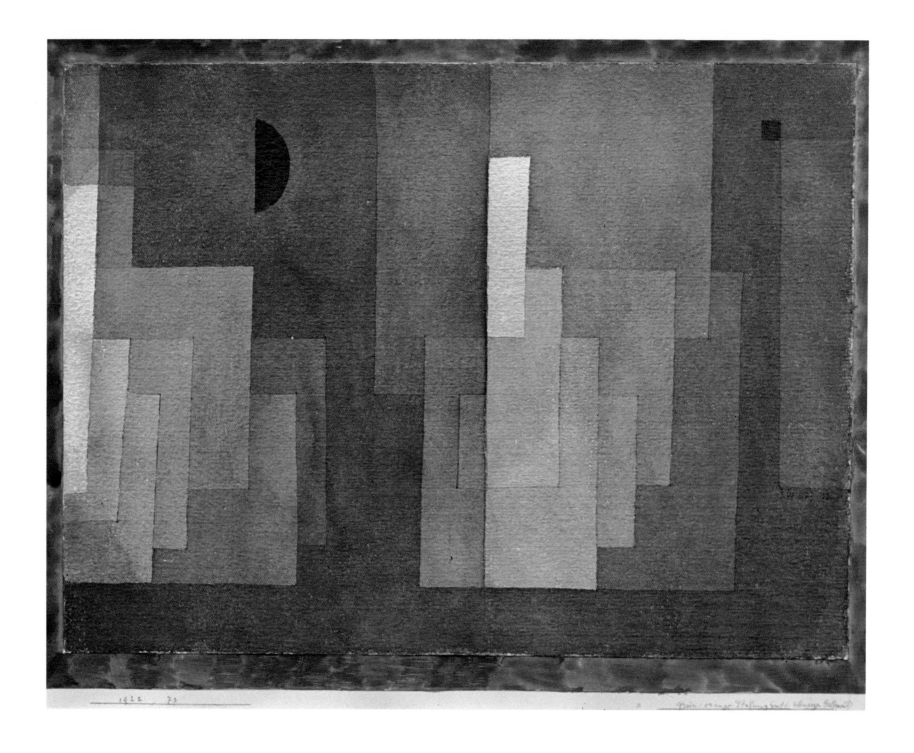

Paul Klee

(1879–1940) *Green-Orange Gradation with Black Half Moon*, 1922, black ink and watercolor over graphite, 29.9 × 39.4 cm. Purchase, Museum Association Fund, 1962.86.

This watercolor was done in 1922, shortly after Klee joined the faculty of the Bauhaus. Particularly subtle in form and color, the structure of the overlapping rectangles creates a scaffolding on which thin washes of luminous tones are applied. There gradually emerges a vision of a remote, abstract world in which the black moon becomes something of a symbol of nature, and the rhythmic changes of color, from warm to cool, imply a spatial differentiation that strengthens the existence of this imaginative realm.

Paul Klee

(1879–1940) *Landscape Wagon No. 14*, 1930, watercolor on grey silk mounted on white card, 47 × 61.6 cm. Museum purchase, 1951.46.

This watercolor, which whimsically combines elements of a cat, vehicle, and landscape, shows two characteristic aspects of Klee's work: the development of his abstractions into representational drawings, and his interest in experimenting with different media. Klee allegedly tore his silk handkerchief, which he used while playing the violin, into two pieces and mounted one half on a white card as a support for the work. The addition of wheels and sticklike trees converts an abstraction into a "landscape wagon."

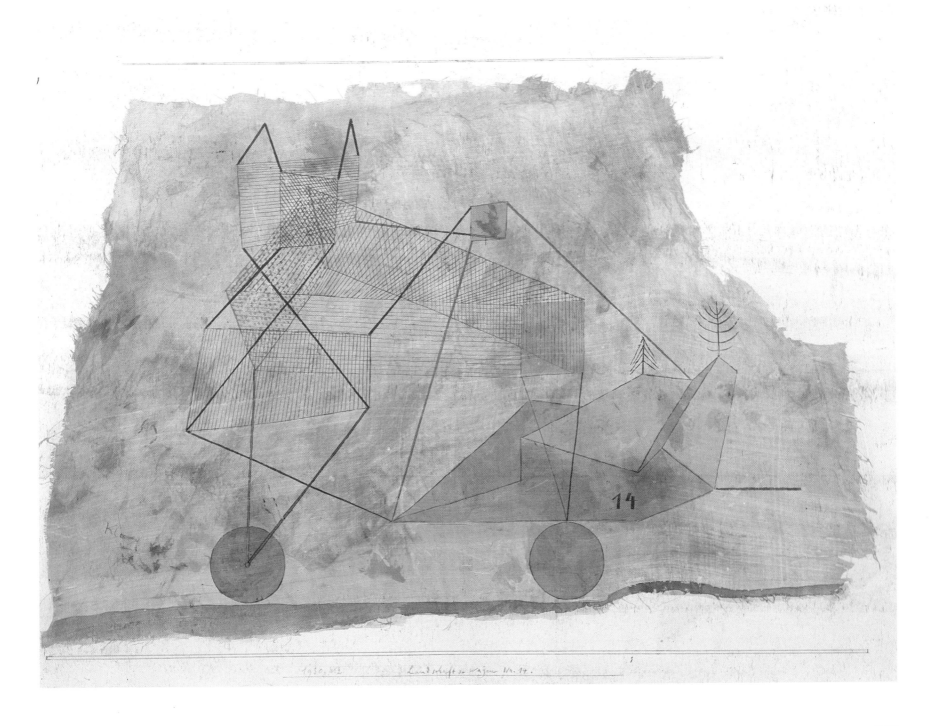

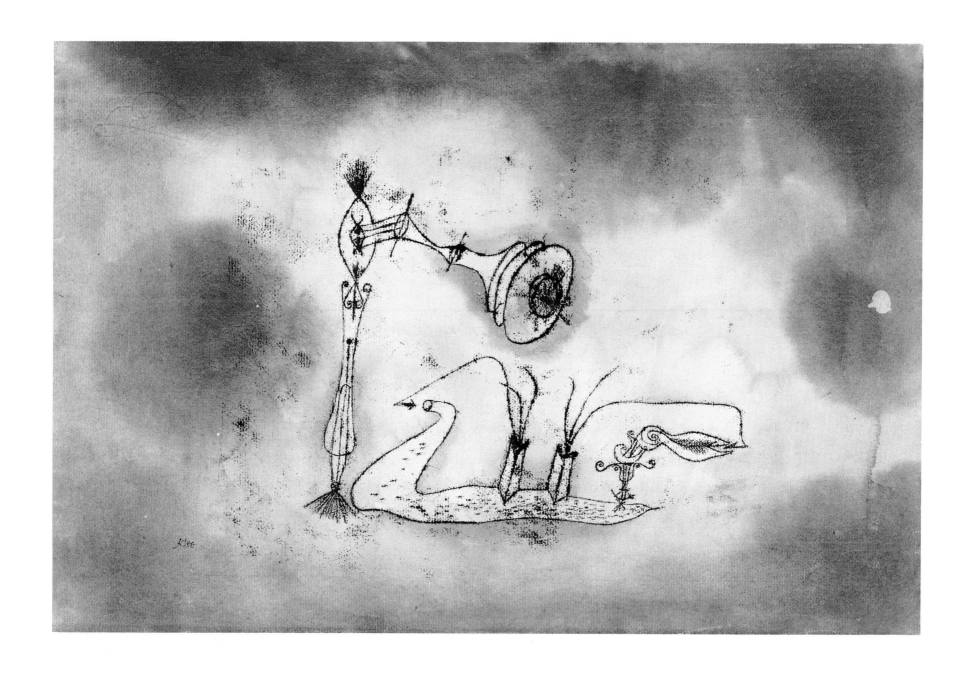

Paul Klee

(1879–1940) *Apparatus for the Magnetic Treatment of Plants*, 1921, oil transfer drawing and watercolor, 31.1 × 47.9 cm. Museum purchase, 1934.80.

Paul Klee

(1879–1940) *Naval Observatory,* 1926, watercolor and gouache, 49.9 × 38.9 cm. Gift, Mr. and
Mrs. Alfred Jaretzki, Jr., 1966.106.

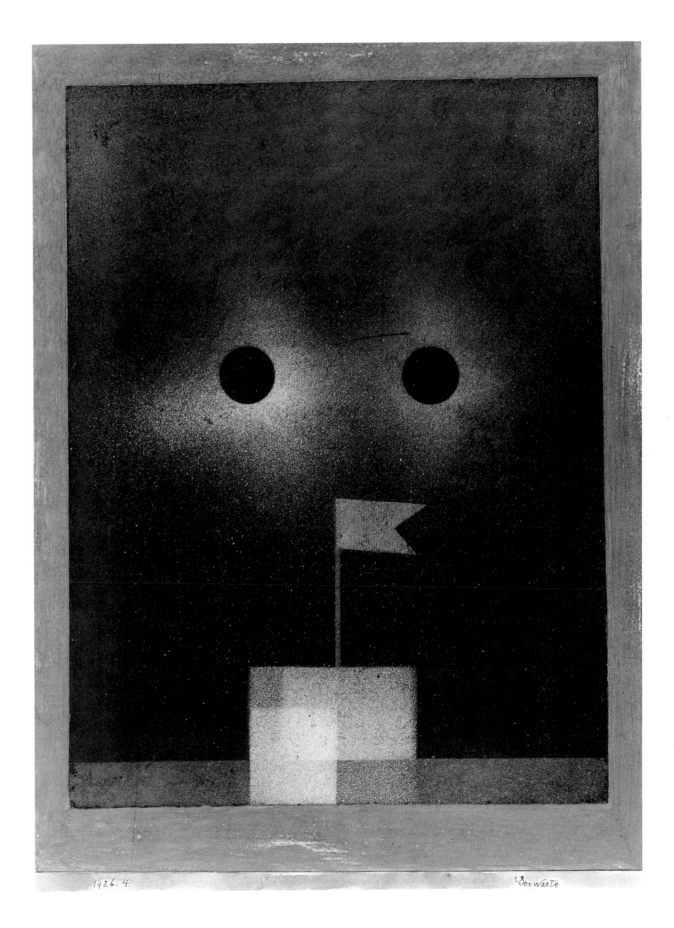

Wassily Kandinsky

(1866–1944) *Landscape,* 1918, watercolor and black ink over graphite on cream paper, 29 × 23 cm. Anonymous gift in memory of Curt Valentin, 1956.50.

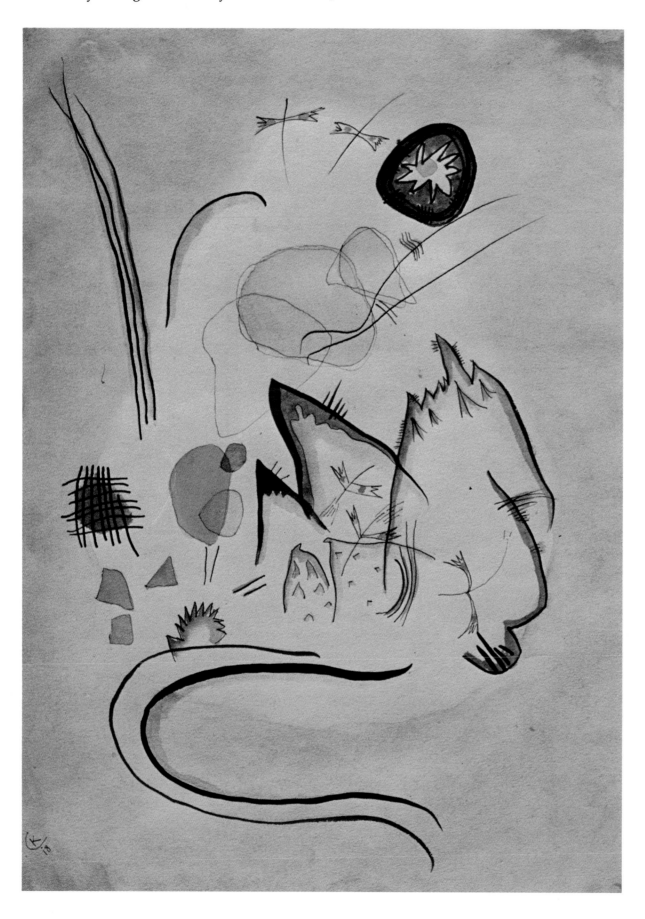

Lyonel Feininger

(1871–1956) *Cloud II*, 1924, watercolor, 28.3 × 40.6 cm. Gift, Mrs. Julia Feininger, 1959.51.
 A study for *Bird Cloud*, page 24.

Wassily Kandinsky

(1866–1944) from the *Kleine Welten* series, No. 6, 1922, woodcut, 27.2 × 23.3 cm. Anonymous gift, 1934.11.
 One of a series of twelve in the Busch-Reisinger collection.

Paul Klee

(1879–1940) *Menacing Head,* 1905, etching, 19.7 × 14.5 cm. Anonymous gift, 1934.28.

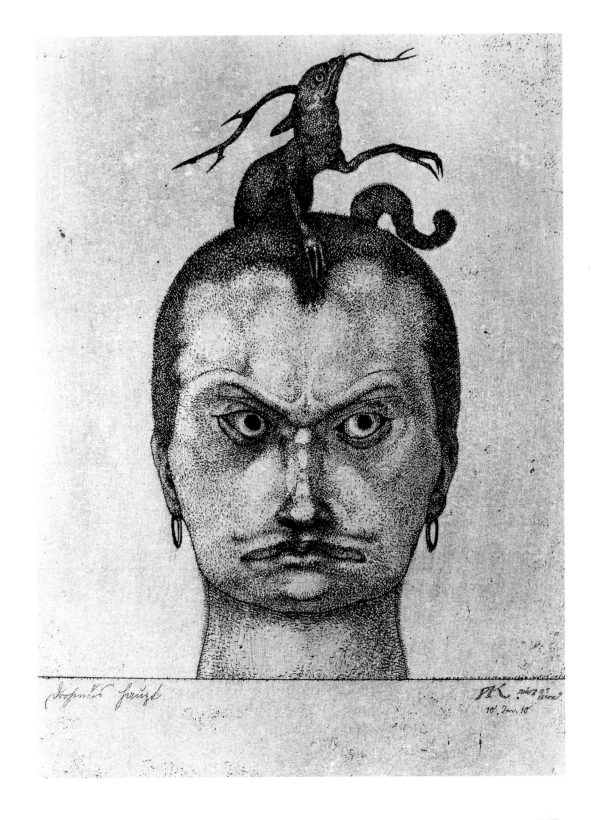

Oskar Schlemmer

(1888–1943) *Figure H2*, 1921, lithograph on pink paper from the Bauhaus portfolio, *Neue Europäische Graphik I*, 36.8 × 14.6 cm. Gift, Mrs. Julia Feininger, 1956.262.

Much of Oskar Schlemmer's art utilizes the human form, but instead of expressing man's personal moods and emotions, Schlemmer aspired to establish a harmonious relationship between man and space, even to the point of presenting man as a machine or marionette. Yet his machined figures, reduced to their most basic elements, are far from lifeless; in them there is a kind of grace and humor.

Schlemmer's *Figure H2* was published as part of the first portfolio issued by the Bauhaus in 1921 at Weimar. These portfolios, published by the Bauhaus Printing Workshop, were part of Gropius's plan to help make the school independent. Avant-garde European artists were also invited to contribute their works to the enterprise, and many accepted the invitation. Today most of the prints published in the portfolios are highly prized. This was not the case when they were first published. The project was a financial failure.

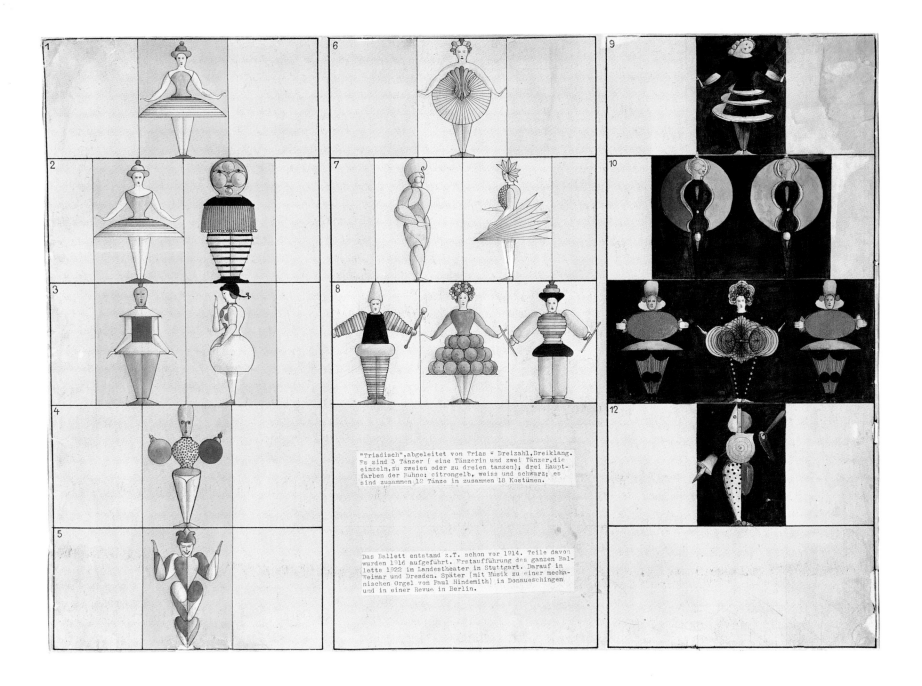

Oskar Schlemmer

(1888–1943) *Costume Designs for the "Triadic Ballet,"* c. 1922, ink, gouache, metallic powder, graphite and collage, 38.1 × 53.3 cm. Museum purchase, 1950. 428.

The *Triadic Ballet* was Schlemmer's major choreographic work. It played an important role in the development of the Bauhaus stage, which was under his direction from 1923 until 1929. The ballet consisted of three parts, and it moved from the humorous to the serious using a lemon-yellow, rose-colored, and finally black stage set. Actors were dressed as marionettes and moved as if by exterior control. The wildly imaginative costumes of which these are examples were the first step in the creation of the work; the choreography and music evolved later. The basic theme of Schlemmer's work is that man exists in a cubical, abstract space, and this space determines costume designs. He often used elements of the grotesque and the comical to parody the conventional stage. The *Triadic Ballet* was performed by two men and one woman; it had twelve different dances and eighteen costumes. Costumes consisted of everything from funnel-shaped legs, coils, glass curls, and accordion chests to goggle eyes and bare-ribbed umbrellas.

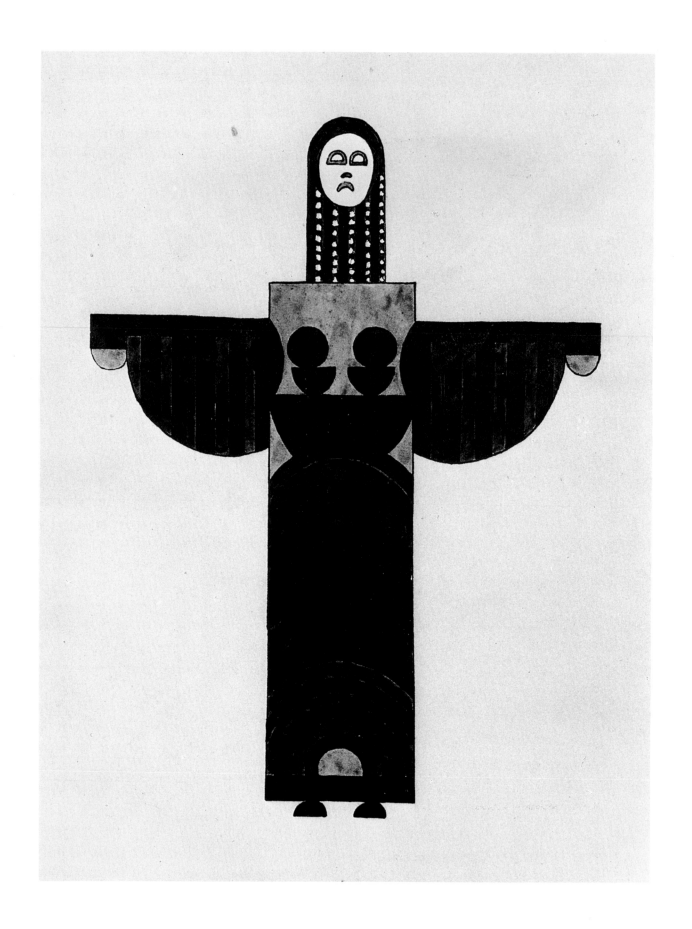

Lothar Schreyer

(1886–1966) *Study for Stage Production, "Kindersterben,"* 1921, color lithograph from the Bauhaus portfolio, *Neue Europäische Graphik I,* 24.9 × 19.3 cm. Gift, Mrs. Julia Feininger, 1956. 265.

This is one example of the numerous twentieth-century costume studies in Harvard collections.

Johannes Itten

(1888–1967) *Proverb*, 1921, color lithograph from the Bauhaus portfolio, *Neue Europäische Graphik I,* 31.8 × 21 cm. Gift, Mrs. Julia Feininger, 1956.254.

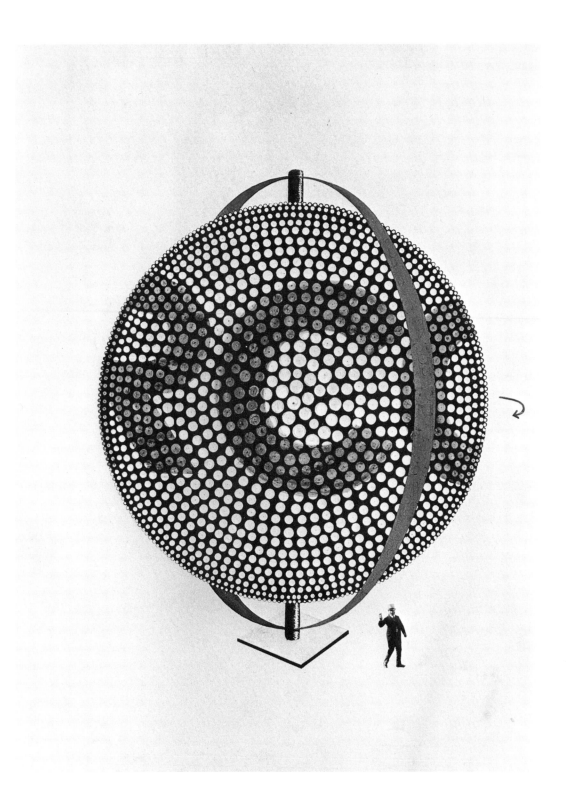

Herbert Bayer

(born 1900) *Illuminated Advertising Sphere,* 1924, ink and gouache, 52.3 × 48.9 cm. Gift, the designer, 1948.105.

First a student at the Bauhaus in Weimar, Herbert Bayer became head of the typography workshop when the school moved to Dessau in 1925. Bayer used simplified type faces, sans-serif fonts, and advocated all lower-case typography. His innovative ideas became inextricably associated with the Bauhaus.

Bayer also did a great deal of work designing advertisements and devising new techniques for exhibitions. He intended this enormous advertising sphere to rotate and have colored electric lights cover it; its message would have been proclaimed in rotating, luminous letters.

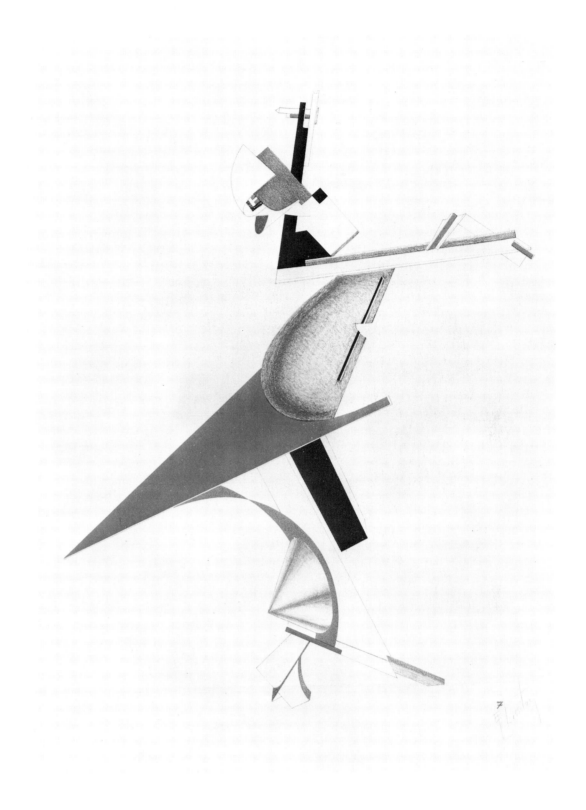

El (Lasar Markovitch) Lissitzky

(1890–1941) *Illustration for "Victory over the Sun,"* 1923, color lithograph, 53.3 × 45.1 cm.
Museum purchase in memory of Louis W. Black, Fogg Museum 14402.

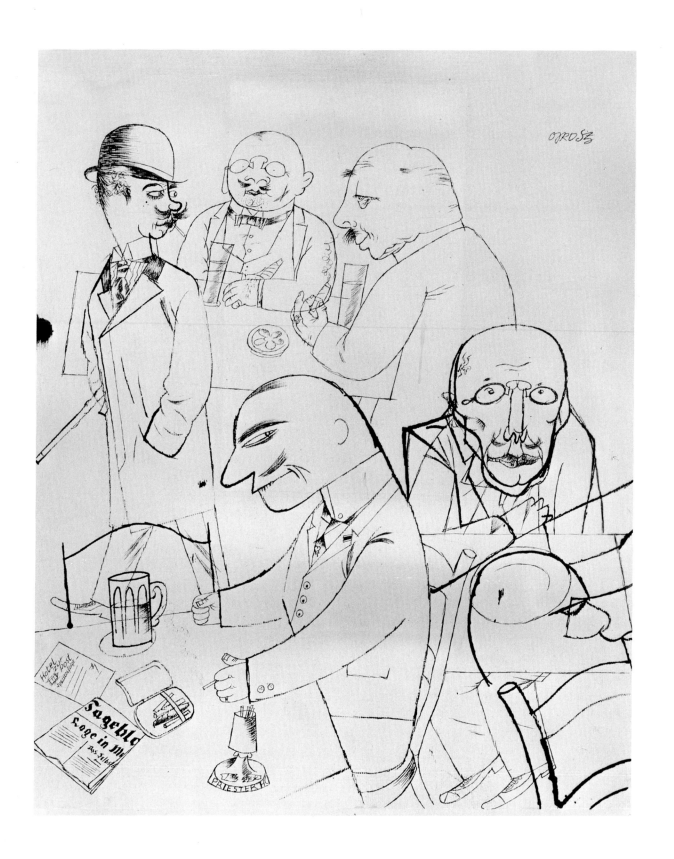

George Grosz

(1893–1959) *Cafe*, c. 1919, ink, 35.5 × 29.2 cm. Museum purchase, 1934.195.

Making his reputation first as a brilliant caricaturist, Grosz became a leading member of the Dada group in Berlin after World War I. From the beginning he dedicated his art to social protest. *Cafe* is one of the numerous biting drawings directed against the materialism of the bourgeoisie and smugness of a society blind to social injustice. The partially visible newspaper headline ("The Situation in M . . . ") may refer to the radical socialist Räterepublik in Munich, which was overthrown in May 1919.

George Grosz

(1893–1959) *Friedrich Ebert*, c. 1923, ink, 64.7 × 51.4 cm. Gift, Erich Cohn, 1964.71.

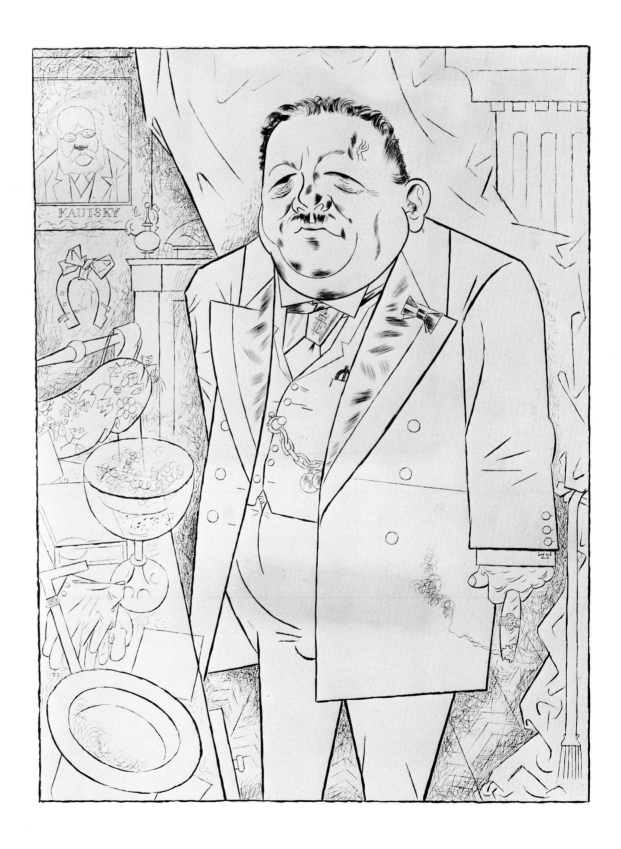

Ernst Ludwig Kirchner

(1880–1938) *Berlin Street Scene (Potsdamer Platz),* c. 1914, colored chalk, 64.8 × 48.3 cm.
Museum purchase, 1950.616.

Erich Heckel

(1883–1970) *Landscape with Bathers*, 1914, watercolor and black chalk on cream paper, 51 × 39 cm. Gift, Mr. and Mrs. Lyonel Feininger, 1954.118.

Erich Heckel

(1883–1970) *Sick Girl*, 1913, woodcut, 14 × 19.1 cm. Gift, D. Thomas Bergen, 1971.53.
 This motif is a reversal of the central panel of the Heckel oil painting *To the Convalescent Woman* in the Museum collection.

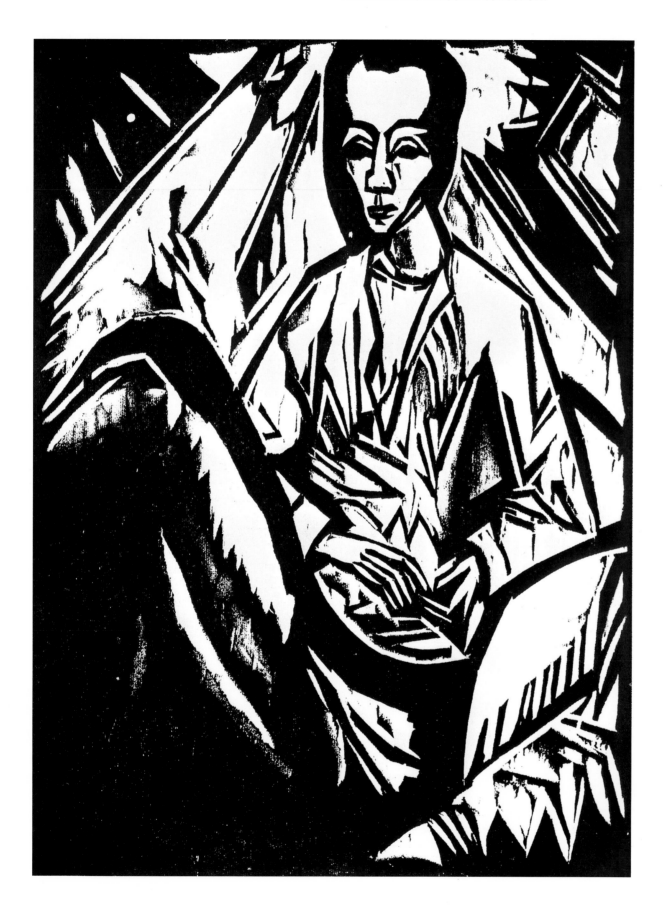

Erich Heckel

(1883–1970) *Brother and Sister,* 1910, black chalk on cream paper, 27.5 × 34.6 cm. Purchase, Loeb Fund and Friends of the Busch-Reisinger Museum, 1978.5.

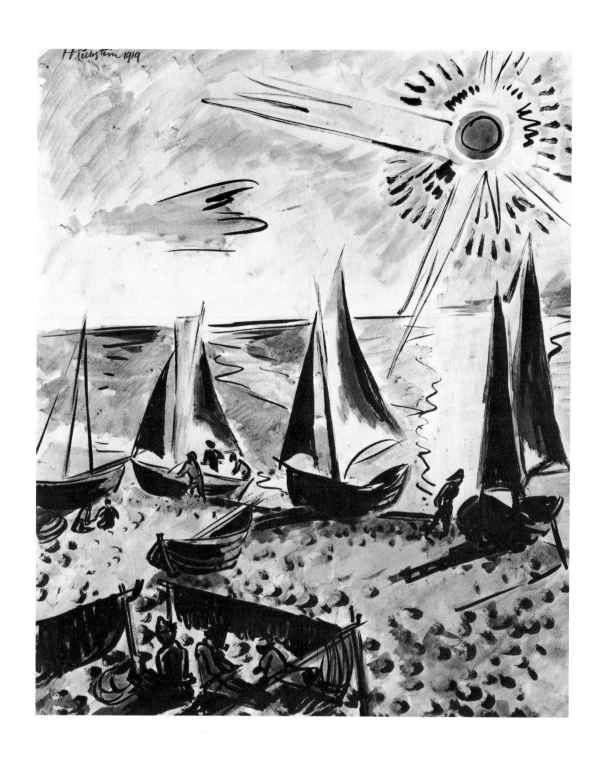

Max Pechstein

(1881–1955) *Fishing Boats,* 1919, watercolor and black ink on tan paper, 58.9 × 45.7 cm.
Anonymous gift, 1951.266.

Max Pechstein joined Die Brücke in 1906, a year after the group was founded. He was the
only member of the group who had a thorough academic training before rejecting the tenets
of more traditional artists. His early schooling gave him a facility that other members of Die
Brücke lacked.

Fishing Boats is one of Pechstein's many beachscapes. It was probably painted on the Baltic
coast, a favorite site of members of Die Brücke before and after the war. The strident fauvist
color of his earlier works is absent from this scene of fishing people mending their nets and
bringing in their boats. Yet a lively effect is achieved by the juxtaposition of the muted colors
of the sand and sea with the harsh black shadows cast by the raking light of the late
afternoon sun.

Karl Schmidt-Rottluff

(1884–1976) *Self-Portrait,* 1913, watercolor and black crayon on brown paper, 43.2 × 33 cm.
Gift, Mr. and Mrs. Lyonel Feininger, 1954.119.

Schmidt-Rottluff was a founding member of Die Brücke at Dresden in 1905; he supplied
the group with its name. During his first years as an expressionist, his palette was
sometimes strident and his line was slack. After settling in Berlin in 1911, where he was
stimulated by fauvism, his colors became more highly saturated, and his line became more
certain and vigorous. These qualities are evident in his 1913 *Self-Portrait.*

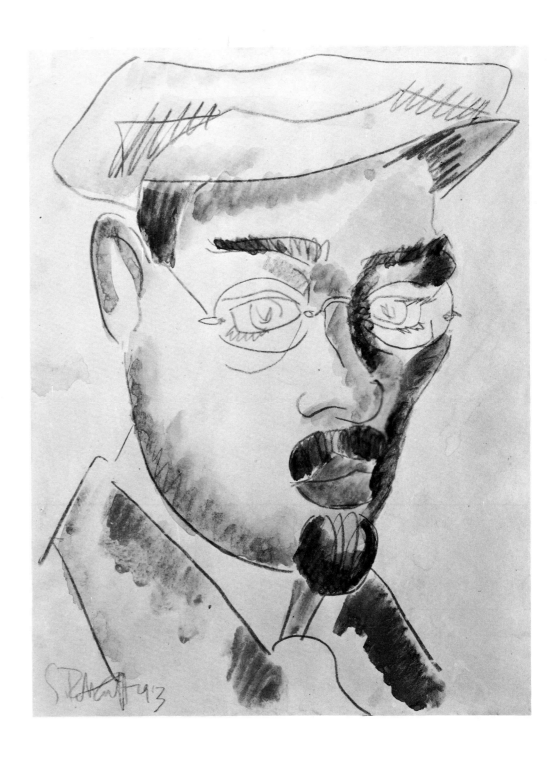

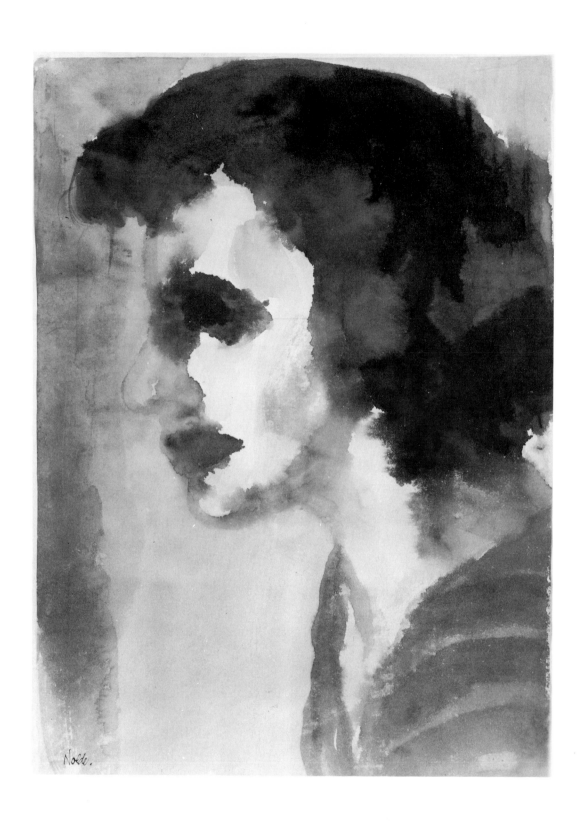

Emil Nolde

(1867–1956) *Head of a Woman with Red Hair,* c. 1920, watercolor on Japan paper, 47 × 34.3 cm.
Gift, Edward M. M. Warburg, 1936.34.

To judge from the numerous watercolors he made during the course of his long career,
Nolde found the medium ideal for expressing his deeply felt emotions.

Long before Nolde picked up his brushes, watercolorists learned that special effects could
be achieved by moistening paper before applying colors to it. What is special about the
technique Nolde used for this portrait is that he used a heavily moistened, highly absorbent
Japan paper. Painting on Japan paper enabled Nolde to use his nearly miraculous control of
the medium to make colors blend and some edges blur. His technique as well as his intense
hues and impetuous brushwork contribute to the visionary effect of the portrait.

Egon Schiele

(1890–1918) *Drapery Study*, c. 1910, watercolor and charcoal on tan paper, 31.1 × 44.5 cm. Purchase, Selma H. Sobin and anonymous funds, 1968.13.

Schiele was an Austrian who received his training at the Vienna Academy of Fine Arts. Later he met Gustav Klimt whose decorative style had a profound impact on Schiele's own work. He is best known for his tortured renderings of emaciated nudes who sometimes exhibit a kind of joyless eroticism. Here, however, Schiele has drawn an unusual work that unites a model's legs to a large expanse of variously colored drapery; he has transformed them to a powerful, abstract form.

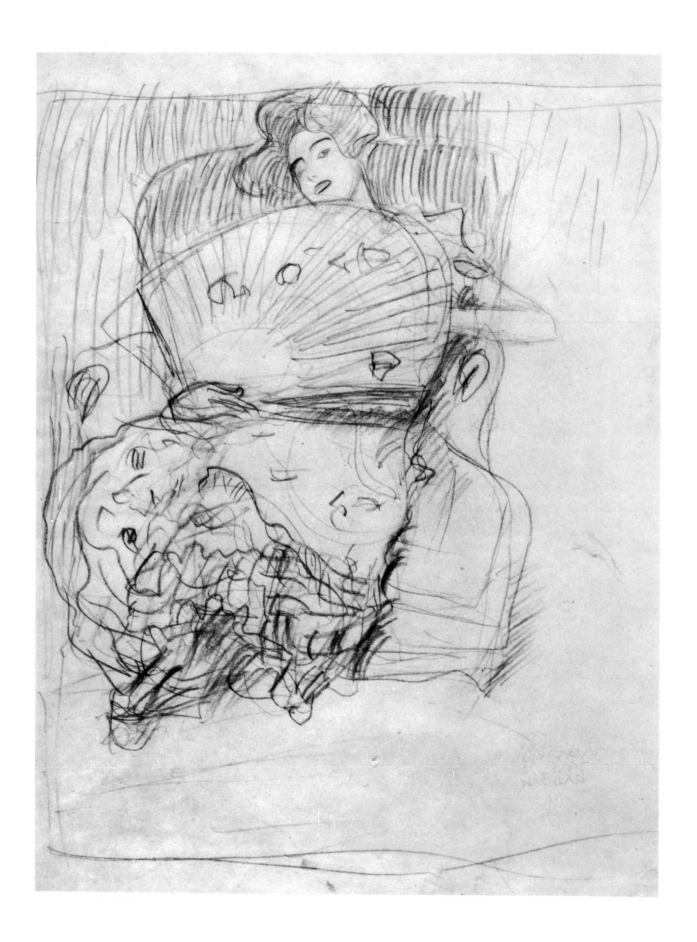

Gustav Klimt

(1862–1918) *Lady with a Fan*, c. 1908, charcoal on brown paper, 45.7 × 31.1 cm. Purchase in memory of Louis W. Black, 1959.34.

Egon Schiele

(1890–1918) *Seated Nude*, 1911, graphite, 53.6 × 38.1 cm. Anonymous gift, 1956.7.

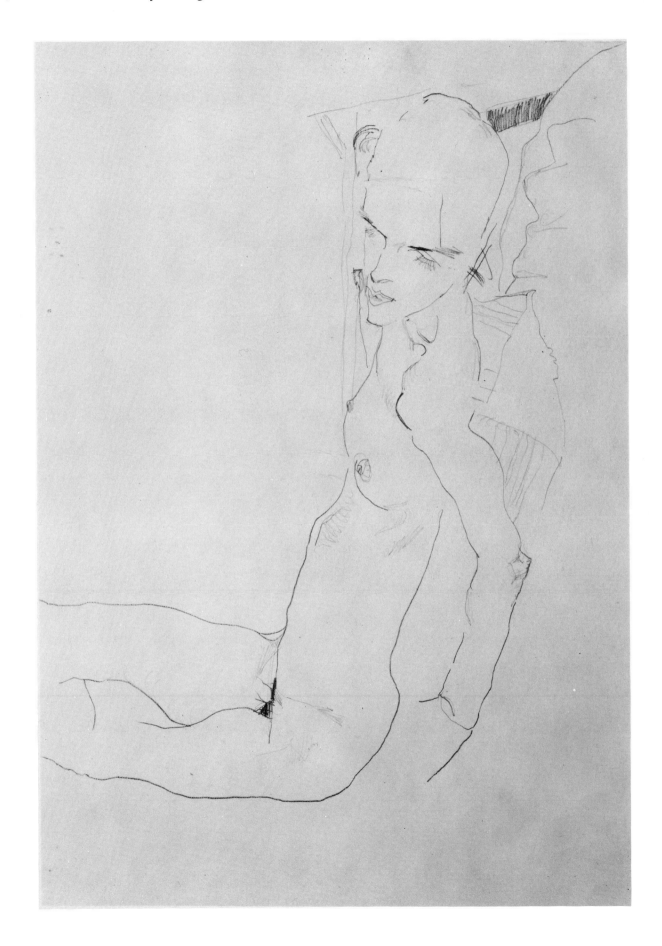

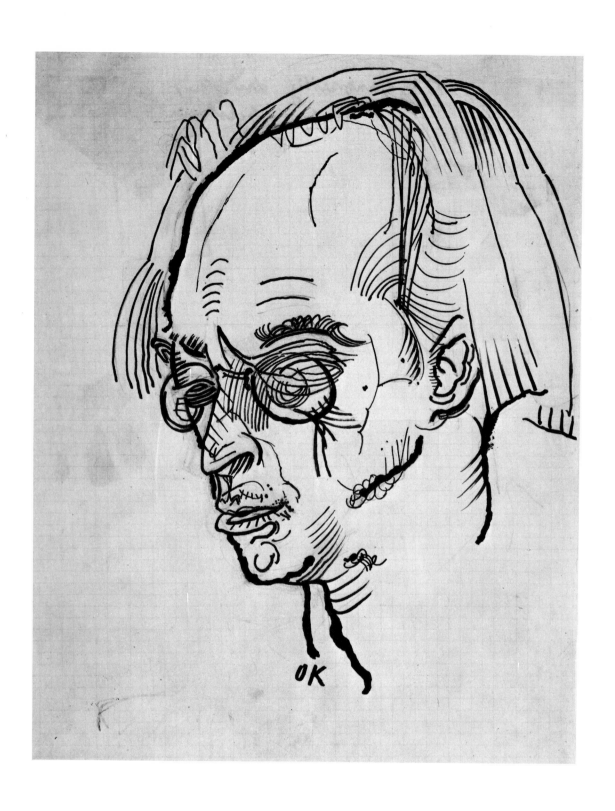

Oskar Kokoschka

(1886–1980) *Portrait of Herwarth Walden*, 1910, pen and ink and graphite on squared paper, 36.2 × 22.2 cm. Purchase, Friends of Art and Music at Harvard, Fogg Museum 1949.137.

Käthe Kollwitz

(1867–1945) *Self-Portrait with Hand to Forehead,* 1910, etching, 15.2 × 14 cm. Purchase, Nutter Fund, Fogg Museum M10,077.

 Although she was of the generation of Munch, Nolde, and Kandinsky, Käthe Kollwitz was largely untouched by the artistic revolutions of the late nineteenth and early twentieth centuries. Her art is firmly rooted in German Naturalism of the 1880s and she never abandoned the social commitment of that movement. Kollwitz made more than fifty self-portraits during the course of her career.

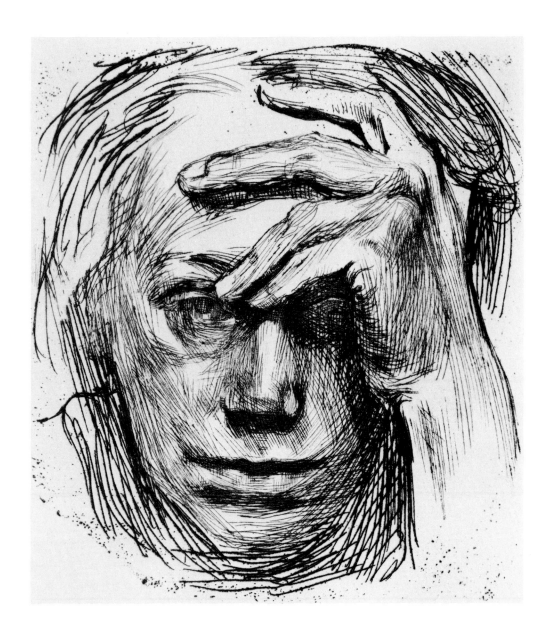

Walter Gropius

(1883–1969) *Design for the Chicago Tribune Competition,* 1922, ink rendering: elevation, 152.4 × 76.2 cm. Gift, Walter Gropius, 1969.59b.

It is fitting that the Busch-Reisinger Museum which has a rich Bauhaus archive also houses the archive of Walter Gropius, founder of the Bauhaus and its director from 1919 until 1928. The Gropius archive includes drawings, plans, models, and photographs that document the career of one of the most creative and influential twentieth-century architects from its beginnings in Germany to the work he did for The Architects Collaborative, the firm he established in Cambridge in 1946.

Gropius's entry done in 1922 for the international competition for the Chicago Tribune Building is an outstanding example of the innovative way he used the skeleton construction of the building as his primary means of architectural design and expression. His entry did not win the competition. First prize was awarded to John Mead Howells and Raymond Hood whose skyscraper was sheathed with ornament derived from Gothic prototypes.

Ernst Barlach

(1870–1938) *Transformations of God: The Seventh Day,* 1921, woodcut, 25.7 × 35.8 cm. Gift, a Friend of the Busch-Reisinger Museum, 1965.148.

The Museum owns the entire *Transformations* series, as well as over one hundred other Barlach prints.

Wilhelm Leibl

(1844–1900) *Portrait of a Man,* 1867, steel pen and carbon black ink on dark brown paper,
27 × 23.4 cm. Bequest, Grenville L. Winthrop, Fogg Museum 1943.530.

Not surprisingly, it was a portrait by Wilhelm Leibl that most impressed Gustave Courbet
during his triumphant visit to Munich in 1869. Unflinchingly direct and unsentimental in its
vision, Leibl's art shares many qualities with that of the master of realism. But as the densely
hatched shadows and dramatic lighting of this portrait show, during his early years Leibl
also emulated the dramatic chiaroscuro effects Rembrandt achieved. Leibl's handsome
young model faces us with a self-confident tranquility that recalls the detachment of a
portrait by Holbein, the artist who exercised the most decisive influence on Leibl's later
work.

Adolph von Menzel

(1815–1905) *An Elderly Man in a Military Topcoat*, 1881, soft graphite, 20 × 12.5 cm. Bequest, Meta and Paul J. Sachs, Fogg Museum 1965.347.

Menzel's drawings are distinguished by a compelling immediacy and strong light effects. The striking resemblance of the subject of this powerful portrait to Bismarck suggests that it may in fact be a study of the Prussian statesman as seen in an unguarded moment. Menzel painted a formal portrait of Bismarck in 1871.

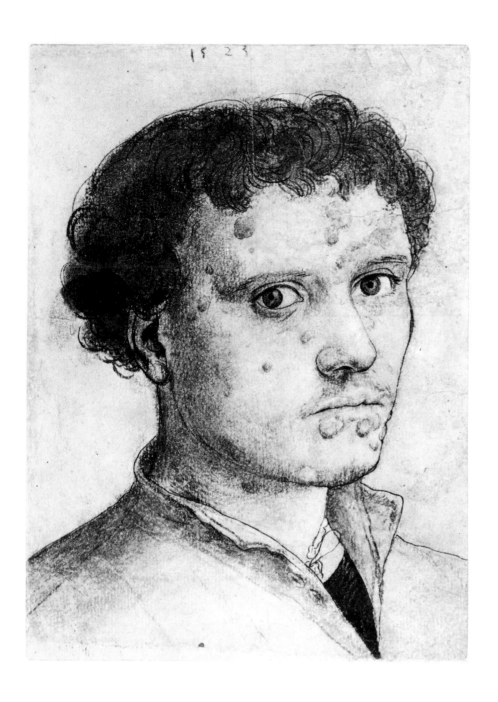

Hans Holbein the Younger

(1497–1543, German School) *Head of a Young Man,* 1523, natural red and black chalks, quill pen and carlson black ink, with washes of ochre on cream paper, 20.5 × 15.2 cm. Gift, Paul J. Sachs, Fogg Museum 1949.2.

This sympathetic portrait of a diseased young man is done in chalks of three different colors, a technique that was reputedly invented by Leonardo and certainly popularized by his immediate Milanese followers. Holbein most probably learned to use the *trois crayons* when he visited Milan in 1518-19.

An old inscription on the verso of the drawing in the hand of Wilhelm Koller, a nineteenth-century collector who formerly owned the drawing, states that it is a portrait of Ulrich von Hütten in the year of his death. Although the resemblance between the model and known portraits of Hütten, a poet and satirist who had contact with the humanists of his day, is not compelling, the identification should not be dismissed out of hand. It is said that Erasmus refused to see Hütten when he was in Basel for fear of contracting his loathsome disease, and it is known that Hütten died in 1523, the year Holbein himself inscribed on the recto of the sheet. More than one dermatologist in recent years has diagnosed the man's ailment as a case of *impetigo contagioso.*

Albrecht Dürer

(1471–1528, German School)
Susanna of Bavaria, 1525, lead
point with traces of
heightening in white on
green prepared paper, 40.3 ×
29.3 cm. Gift, Meta and Paul
J. Sachs, Fogg Museum
1949.1.

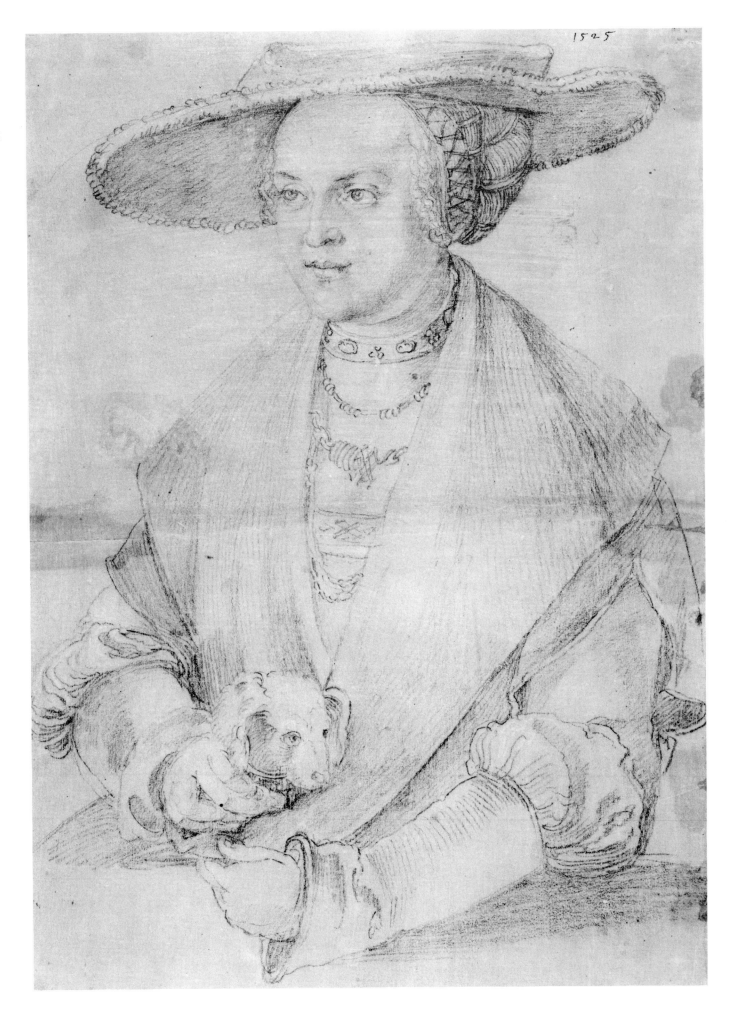

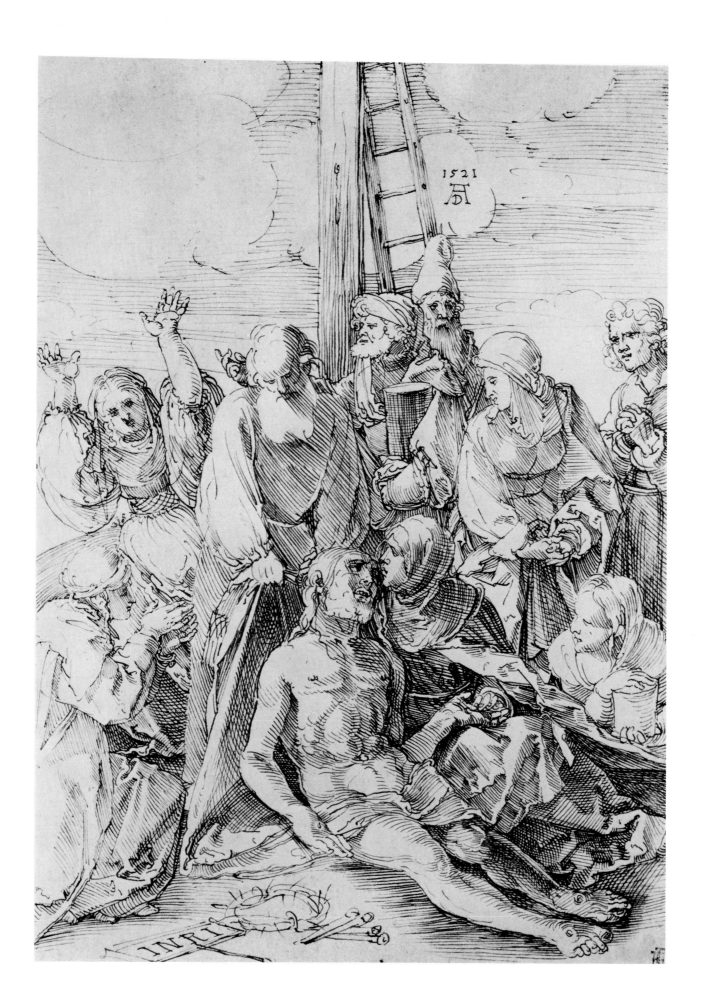

Albrecht Dürer

(1471–1528, German School)
Lamentation, 1521, pen and
brown ink, 29 × 21 cm.
Bequest, Meta and Paul J.
Sachs, Fogg Museum
1965.339.

Themes from the Passion
occupied Dürer, the greatest
German Renaissance artist,
throughout the course of his
career. His late drawing of the
Lamentation is an outstanding
example of the emotional
intensity and dignity with
which he endowed a tragic
subject as well as the
lightness and openness his
brilliant penmanship
achieved during his maturity.

Martin Schongauer

(c. 1450–1491, German School) *Virgin of the Annunciation,*
c. 1490–91, engraving, 17 × 11 cm. Fogg Museum G 4969.

In his day Martin Schongauer was the most famous artist
in Germany. It was with him that the young Dürer hoped to
study, but when he arrived at Schongauer's workshop in
Colmar in 1492 the artist had been dead almost a year. The
Virgin of the Annunciation, datable to Schongauer's last
years, shows what attracted the young Dürer to the master:
the strength and refinement of his figures and the clarity of
form he achieved by combining crisp, long strokes with an
intricate system of hatching. These are qualities found in
Dürer's early engravings.

The companion piece to Schongauer's *Virgin of the
Annunciation* is a print of the *Annunciate Angel.*

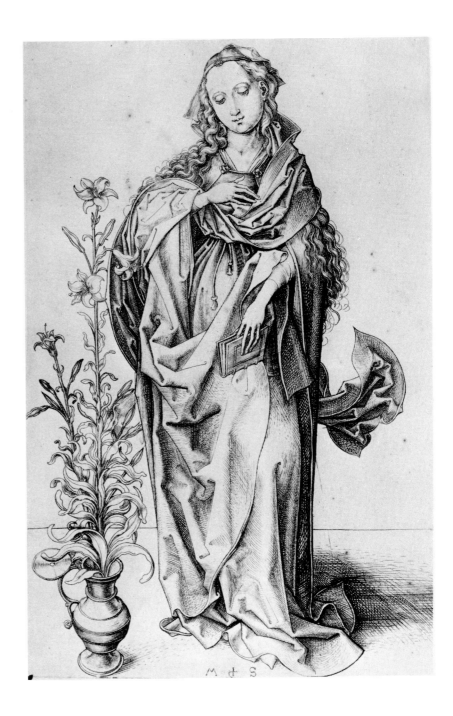

INDEX OF ARTISTS

Photographic Credits
David Finn and Amy Binder: Pages 1–14, 16, 22, 28, 31, 33, 34, 35, 38, 41, 43, 44, 61–74, 75–80, 82–89, 92–108, 110, 114, 130.
All other photographs furnished by the Fogg Photographic Services, headed by Michael Nedzweski.